2

2 9

18

2 t

Janis Hendrickson

Roy Lichtenstein

Benedikt Taschen

FRONT COVER:
I Know How You Must Feel, Brad (detail), 1963
Oil and magna on canvas, 168 × 96 cm
Aachen, Ludwig Forum für
Internationale Kunst

ILLUSTRATION PAGE 2:
Two Paintings: Dagwood, 1983
Oil and magna on canvas, 228.6 × 162.6 cm
Private collection

BACK COVER:
Roy Lichtenstein in his studio, 1985
Photo: Grace Sutton

This book was printed on 100 % chlorine-free bleached paper in accordance with the TCF standard.

© 1994 Benedikt Taschen Verlag GmbH
Hohenzollernring 53, D-50672 Köln
© 1993, for the reproductions: VG Bild-Kunst, Bonn
Cover design: Angelika Muthesius, Cologne

Printed in Germany
ISBN 3-8228-9633-0
GB

Contents

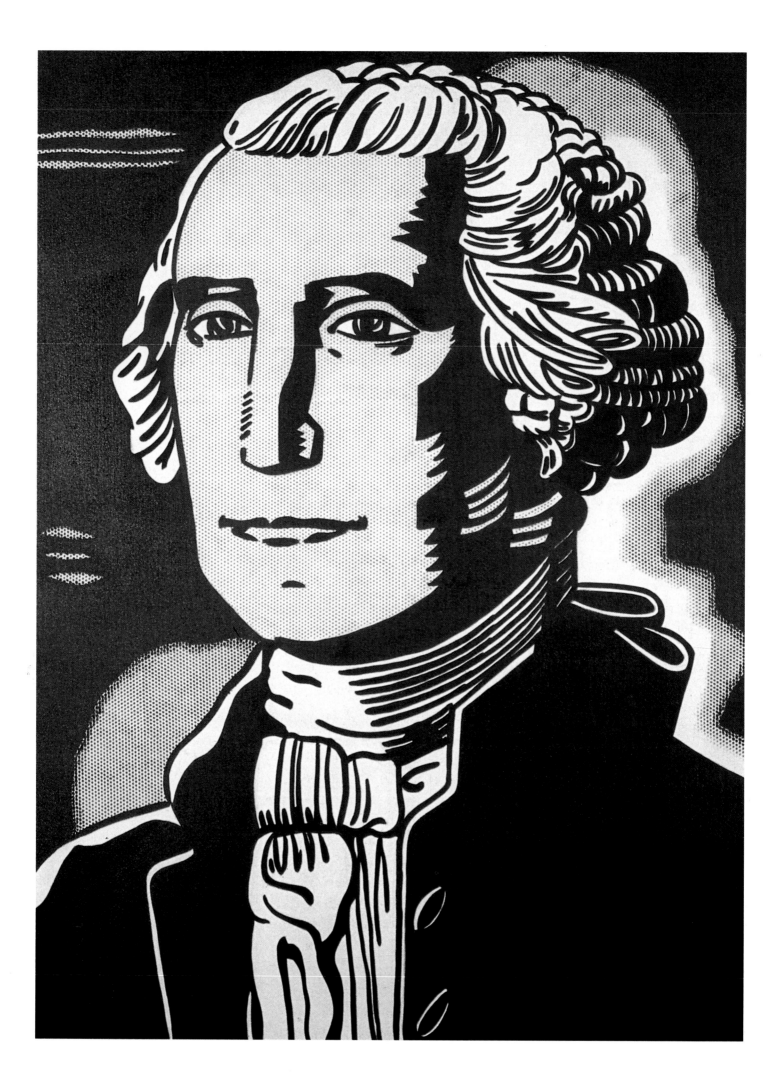

The Beginnings

A "founding father" of Pop Art? Maybe it is only a coincidence that the portrait of George Washington first sketched in pencil and then executed as an oil painting by Roy Lichtenstein in 1962 now so closely resembles the artist himself. The large, wide-set eyes and the taut, nearly square face he shows certainly have little to do with the flesh physiognomy of the first president of the United States. However, this can be easily explained: a Hungarian did it. The printed source Lichtenstein says he used was not a one dollar bill, as one might expect, but of all things a Hungarian-language newspaper that had printed a linocut adaptation of one of Gilbert Stuart's famous portraits.

Still, somehow the autobiographical association seems appropriate. By 1962 Lichtenstein had established himself as a leader in the American art world. A year earlier he had not only discovered a style of painting that suited his understated yet irreverent sense of humor, but he had been taken on by the prestigious New York gallery of Leo Castelli. Soon he was to quit teaching in order to devote all of his time to painting. Although *George Washington* (Ill. p. 6) is not one of the comic strip paintings with which Lichtenstein is most immediately identified, the "portrait" might be understood as a typical work since it contains many of the ideas we will encounter him exploring during his artistic career. First, the subject is well-known, both heroic and banal, even corny. Second, the image is taken from a cheapened reproduction of an eighteenth century American painting – a work that the original artist himself, Gilbert Stuart, had already reproduced in more than one hundred hand-painted replicas. Thus Lichtenstein's Washington might well be a reproduction of a reproduction of a reproduction of an original, an absurd aspect not without its humor. Third, Lichtenstein's painting technique clearly refers to his mass-produced, printed source.

However, even though he did achieve a breakthrough, he had had to wait for it. In 1962 Roy Lichtenstein was nearly forty years

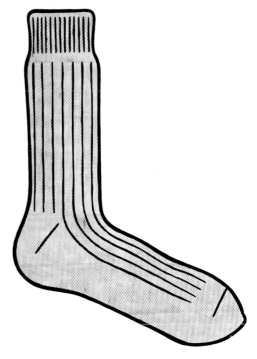

Sock, 1961
Oil on canvas, 121.9 × 91.4 cm
Aachen, Neue Galerie – Collection
Ludwig

George Washington, 1962
Oil on canvas, 129.5 × 96.5 cm
New York, Collection Jean Christophe
Castelli

old and he had only a semi-successful, rather non-spectacular career behind him. Born in 1923 into a middle-class family in New York City, he appears to have led a "normal" and happy childhood. His father was a realtor who specialized in managing garage properties and parking lots. If there were any artistic streaks in the family, Lichtenstein has never bothered mentioning them in any of his biographical statements. He attended a public school until the age of twelve, and then he enrolled in a private academy for his secondary education. There were no art classes there, yet somehow Lichtenstein became interested in drawing. He began to draw and paint in oils at home as a hobby. Around the same time he became a jazz fan and attended concerts at the Apollo theater in Harlem and in jazz clubs on 52nd Street. He made portraits of musicians, often showing them playing their instruments, much as did the American artist Ben Shahn. As a very young man, Lichtenstein was prowling the city for the most exciting cultural inspiration it could offer. His attraction to jazz says something about the direction he was to take in the visual arts: he shared the Cubist predilection for black culture, which made itself felt not only in a love of African art but also in a taste for American jazz. During his last year at the academy (1939), Lichtenstein enrolled in summer art classes at the Arts Students League in New York under Reginald Marsh. Lichtenstein says that Marsh was seldom on hand to look at student work, so that no real personal relationship could develop between the two. Yet since Marsh was Lichtenstein's first teacher, it is useful to consider his possible influence – or anti-influence – briefly. Marsh was one of a number of American artists that subscribed to a national art centering on everyday American themes painted or drawn in an easily readable, nearly caricature-like way. The world of recognizable things is featured in his art. He rejected abstract European avantgarde art such as Cubism and Futurism. These movements had become more widely known, or from Marsh's point of view, notorious, after they had been introduced in the United States through the Armory Show in 1913. Yet such avantgarde movements had no effect on Marsh's work, indeed he remained rather militantly picturesque. He was attracted to the masses, whose faces he caught in fleeting brushstrokes. City scenes full of color and movement – the amusement park and beach, Coney Island or the subways – offered him all the subject matter he could desire.

While Lichtenstein was at the Art Students League he, too, sketched similarly vernacular slices of New York life: the Bowery, carnival scenes, boxing matches and beach scenes. Lichtenstein had very much admired Picasso, whose work he knew through reproductions and whose blue and rose periods had slightly influenced his early drawing. It might well have been disappointing for the young Lichtenstein to find these European developments in painting form

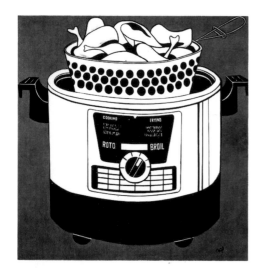

Roto Broil, 1961
Oil on canvas, 174 × 174 cm
Beverly Hills (Ca.), Collection Mr. and
Mrs. Melvin Hirsch

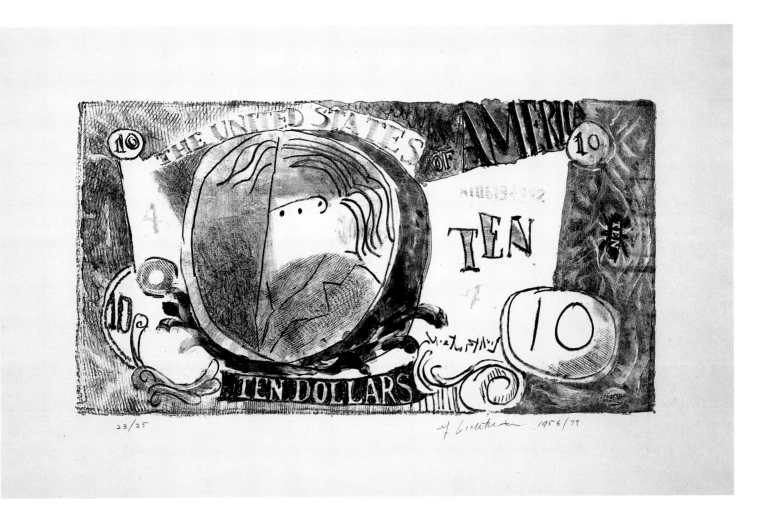

23/25 1956/79

Ten Dollar Bill, 1956
Lithograph, 14 × 28.6 cm
Collection of the artist

so heartily rejected by his teacher. Still, Marsh's kind of non-academic, clearly American art that used everyday, regional subject matter is directly related to Pop's celebration of banal and common things. The main difference exists in the attitude with which Pop artists will approach their everyday subject matter: George Washington and all of the Americanisms he represents will fall victim to irony.

After Lichtenstein graduated from high school in 1940, he was sure that he wanted to become an artist. His parents supported him in this decision, although they were worried about him being able to make a living. They encouraged the young Lichtenstein to get a teaching degree from a regular liberal arts college, so that he could fall back upon a real profession if need be. Apparently Reginald Marsh's conservative attitude towards painting did not entirely please Lichtenstein, who was willing to leave the big city for Ohio State University. Although this step may seem strange today, New York was not the art metropolis then that it became after the war, and Lichtenstein saw no compelling reason to stay "at home" at the Art Students League with its emphasis on regional painting. Ohio State offered studio courses and a degree in fine arts. Although his education was interrupted by a three-year stint in the army, he returned to Ohio and finished his undergraduate education there. One of his teachers, Hoyt L. Sherman, proved highly influential.

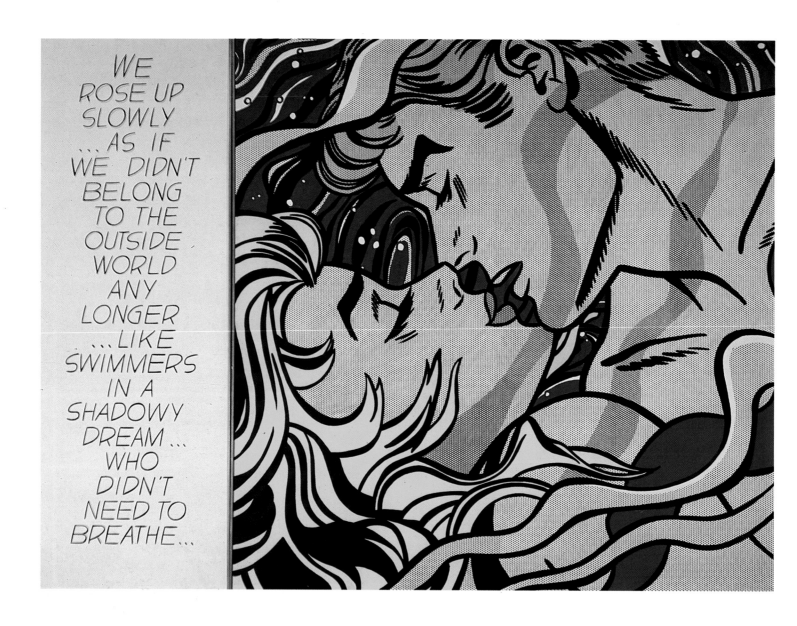

We rose up slowly, 1964
Oil and magna on canvas,
two panels 173 × 234 cm
Frankfort, Museum für Moderne Kunst

Sherman taught all kinds of liberal arts students in his classes, and he had developed an unusual way of sharpening their powers of perception. He used a "flash room", a darkened room where images would be briefly flashed onto a screen and then disappear. The student was supposed to draw what he or she had seen. The flashed images were simple at first and became increasingly complex as the semester proceeded. The more complex arrangements used forms grouped into patterns. Finally, real objects were suspended from the ceiling and flashed with a spotlight. Interestingly enough, Sherman used up to three projection screens, so that he could fracture the projected images by varying the depth of the screen. As Lichtenstein described it, "You'd get a very strong afterimage, a total impression, and then you'd draw it in the dark – the point being that you'd have to sense where the parts were in relation to the whole ... It was a mixture of science and aesthetics, and it became the center of what I was interested in. I'd always wanted to know the difference between a mark that was art and one that wasn't. Sherman was hard to understand, but he taught that the key to everything lay in what

he called perceptual unity." Eventually, the student was supposed to use his sharpened, analytic vision without the aid of the flash room. The last step of this educative process included drawing from life. What seems to have had the most lasting effect on Lichtenstein was Sherman's idea that vision was more an optical process than a narrative or emotional experience. Sherman's method of intellectually grasping an existing image by copying it also made a deep impression on his student.

What Lichtenstein learned from Sherman about translating vision into an image focused on the formal organization of the composition. What the picture actually showed was second in importance to the way it presented itself. In Sherman's book, *Drawing by Seeing*, he claimed that students must develop the ability of perceiving even the most familiar of everyday objects as a purely optical experience, as emptied of meaning as possible. This experience was then to be translated into one of position and brightness. For Sherman, an artist's thinking had always to be ground-directed. This part of his education had a profound influence on Lichtenstein. Later, Pop art would seem to ignore the artist's involvement with the painting ground. Instead, Pop would pretend

Look Mickey, 1961
Oil on canvas, 121.9 × 175.3 cm
Collection of the artist

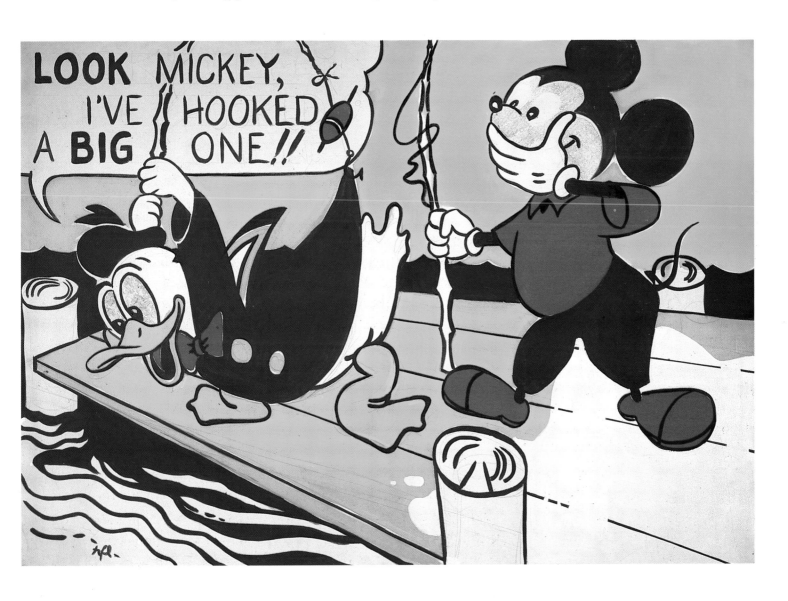

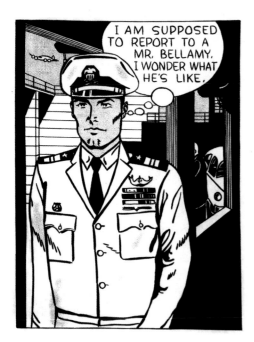

Mr. Bellamy, 1961
Oil on canvas, 143.5 × 107.9 cm
Collection Vernon Nickel

I Know ... Brad, 1963
Oil and magna on canvas, 168 × 96 cm
Munich, Bayerische Staatsgemälde
Sammlungen
Aachen, Sammlung Ludwig

to be involved only with the object itself. Yet Lichtenstein emphasized the tension between the apparent object-directedness and the unavoidable ground-directedness of Pop painting. He found this tension one of the main strengths of his imagery, and what is more, he found it humorous.

Certainly earning a college degree had not been all that common for artists up until that point, yet it proved essential to Lichtenstein's career. Lichtenstein entered the graduate program at Ohio State and was hired as an art instructor – a job he returned to on and off for the next ten years. This intellectual context is important to his art work since it could have strengthened an analytic tendency; Lichtenstein was less interested in giving expression to an inner feeling or documenting reality than he was in examining art and art processes. Sherman, himself an engineer, had also encouraged Lichtenstein to take drafting classes. The artist feels that this background in mechanical drawing nurtured the objective, non-emotional side of his art.

Up until 1950 Lichtenstein was painting mainly semi-abstract pictures that were influenced by the late Picasso, Braque and Klee. He had been included in several group shows in the Mid-west and in 1951 he had his first one-man exhibition in a gallery in New York. There he showed paintings using knights in armor and medieval castles within a delicately abstract framework. The exhibition was a minor success: enough of the paintings were sold to pay for the framing and shipping. By 1951 the post-war surge of students who had taken advantage of the G. I. Bill was beginning to diminish and Lichtenstein was not re-hired at Ohio State as an instructor. Because his wife had a job in Cleveland, they moved there and remained in Cleveland for the next six years. Lichtenstein took on various jobs. He worked as an engineering draftsman, a window decorator and a sheet metal designer. Bouts of work alternated with bouts of painting. And what Lichtenstein had decided to paint may seem rather odd at first.

Apparently Lichtenstein was not interested in working with live models, actual cityscapes or still life themes. Nor was he tempted by pure abstraction. Strangely enough, he began to subject uniquely American works of art such as Western frontier paintings by Frederic Remington or Charles Willson Peale to a Cubist treatment. The reasoning behind this is unclear, but it was a jarring confrontation between American subject matter and a European style of painting. (Remington, who died fairly young in 1909, painted some of his most convincing cowboy and Indian pictures at the same time Picasso was developing Cubism.) In these paintings, Lichtenstein's brushwork was loose and fleeting. It was as if he wanted to paint American scenes but did not feel comfortable with a head-on, straight approach. He experienced the West as a self-

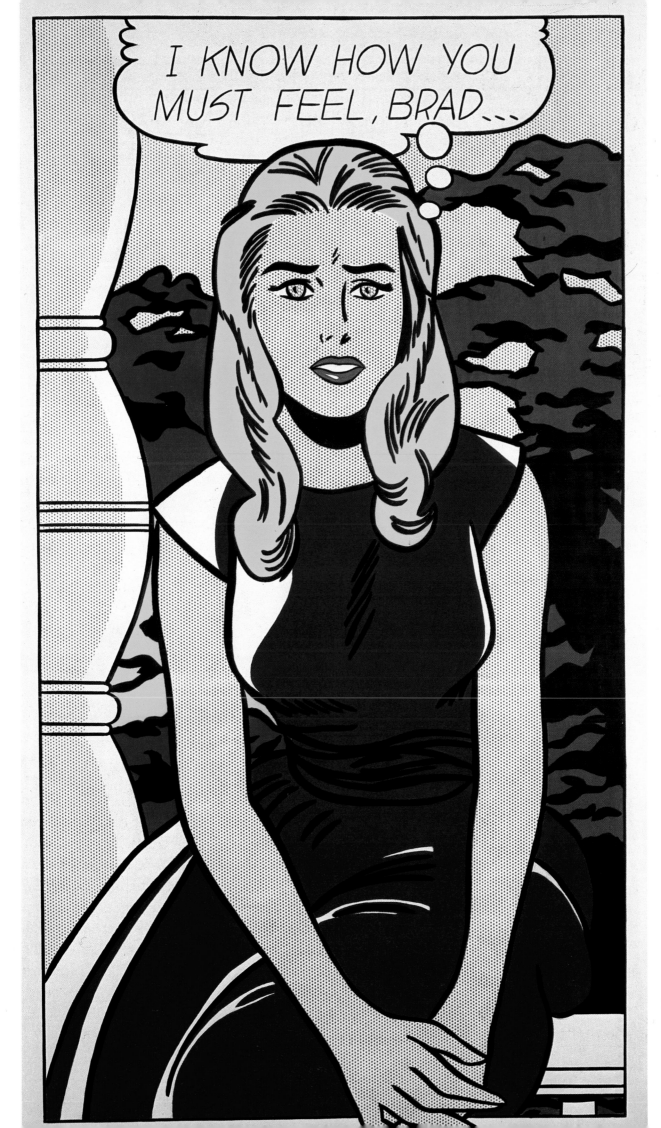

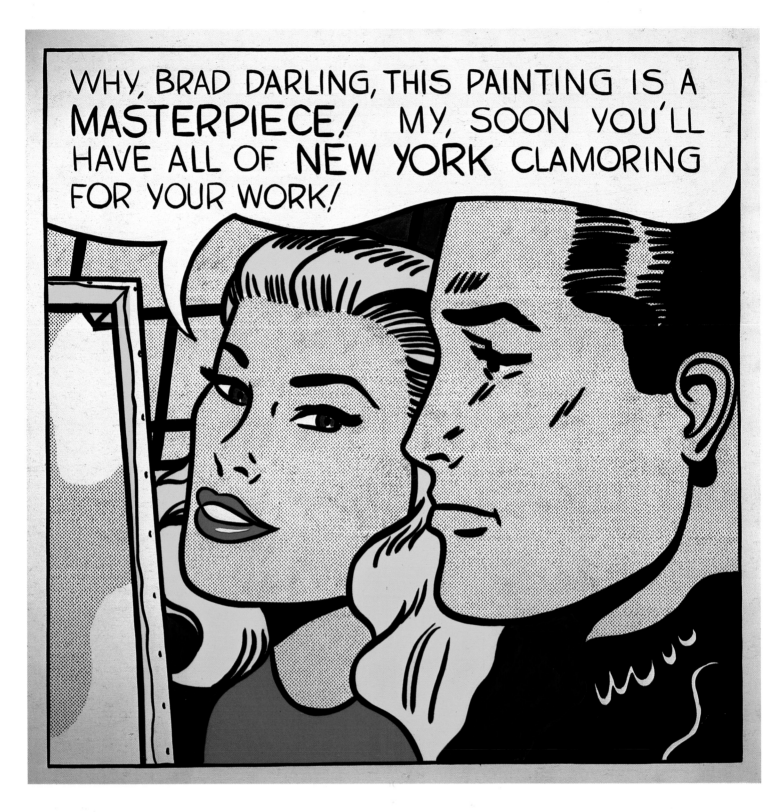

Masterpiece, 1962
Oil on canvas, 137.2 × 137.2 cm
Beverly Hills (Ca.), Collection Mr. and
Mrs. Melvin Hirsch

conscious, twentieth century painter who might admire the bygone
authenticity of a cowboy without actually being able to identify
with him. It was a very removed kind of history painting. The same
sort of imagery – cavalry, Indians, but also knights in armor – was
created in assemblages Lichtenstein made of found wooden and
metal objects. During these early years, Lichtenstein was busy
experimenting. He was playing with the media and
structures of European modernism by applying them mainly to
Americana.

A lithograph of a ten dollar bill (Ill. p. 9) that he made in 1956 shows just how humorous this marriage of established art forms and Americana could become. Lichtenstein almost seems to be forging money; his lithograph is a brand new bill of tender and not a picture of one. The rectangular shape of the paper upon which the image is printed has about the same proportions as the currency and the image fills out the entire surface of the rectangular form. However, the medallion portrait of President Hamilton shows him as a planar, anteater-like being with the hair-do of the young Picasso and a row of eyes like a figure by Francis Picabia. The complicated framing design has been altered, or rather simplified in an imbalanced, drunken fashion. As Lichtenstein said, "That was when I first got the idea of doing really simple-minded pictures that would look inept and kind of stupid, and the color would look as though it wasn't art." It is "funny money" alright, although even describing it seems to take some of the air out of the joke. This is a phenomenon that often happens when a Lichtenstein work is carefully analyzed. Somehow his wit, so dependent on an unspoken recognition and immediate enjoyment of the changes he has effected in his subject matter, can become a little flat when it is explained away.

Although Lichtenstein showed his work regularly in New York during the fifties, he was not selling enough to support his family, which by 1956 included two sons. In 1957 he decided to go back to teaching and was offered a job at Oswego, a small college in upstate New York where he taught for the next three years. In Oswego he stopped painting his "historical" subject matter and adopted another style of painting that had since established itself internationally: Abstract Expressionism. Abstract Expressionism exists in extroverted and introverted forms. The extroverted Action Painting added artist energy, improvisational technique, paint and sometimes things like cigarette butts or glass together and spread, dripped or smeared them out on large canvases. Jackson Pollock and Willem de Kooning stressed such direct expressive execution and became figureheads for the active style. In contrast, the more introverted Symbolic Abstract Expressionism and Color-Field Painting was deeply immersed in its feeling for color and shape. Paintings by such artists as Robert Motherwell and Barnett Newman have a subtle, sensitive and more deliberate clarity. Newman painted large, pure fields of color which encouraged the viewer to meditatively immerse him or herself in the picture. Whether agitated or refined, the Abstract Expressionists usually abandoned recognizable imagery for abstract surfaces. (Willem de Kooning is the exception.) All of these paintings have something to do with the artists' innermost thoughts and feelings.

Long after Pop Art had become history, Andy Warhol characterized the Abstract Expressionists in a way that revealed a typical

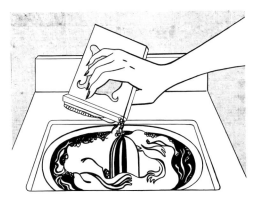

Washing Machine, 1961
Oil on canvas, 143.5 × 174 cm
New York, Collection Richard Brown Baker

"We like to think of industrialization as being despicable. I don't really know what to make of it. There's something terribly brittle about it. I suppose I would still prefer to sit under a tree with a picnic basket rather than under a gas pump, but signs and comic strips are interesting as subject matter. There are certain things that are usable, forceful, and vital about commercial art. We're using those things – but we're not really advocating stupidity, international teen-agerism, and terrorism."
ROY LICHTENSTEIN

Pop antagonism towards them: "The world of the Abstract Expressionist was very macho. The painters who used to hang around the Cedar bar on University Place were all hard-driving, two-fisted types who'd grab each other and say things like 'I'll knock your fucking teeth out' and 'I'll steal your girl'. In a way, Jackson Pollock had to die the way he did, crashing his car up, and even Barnett Newman, who was so elegant, always in a suit and monocle, was tough enough to get into politics when he made a kind of symbolic run for mayor of New York in the thirties. The toughness was part of a tradition, it went with their agonized, anguished art. They were always exploding and having fist fights about their work and their love lives ... The art world sure was different in those days. I tried to imagine myself in a bar striding over to, say, Roy Lichtenstein and asking him to 'step outside' because I'd heard he'd insulted my soup cans. I mean, how corny. I was glad those slug-it-out routines had been retired – they weren't my style, let alone my capability."

Abstract Expressionism was the backdrop for new developments that had already started by 1957, just when Lichtenstein, a

Sunrise, 1965
Offset lithograph in red, blue and yellow,
46.7 × 62 cm
Cologne, Museum Ludwig

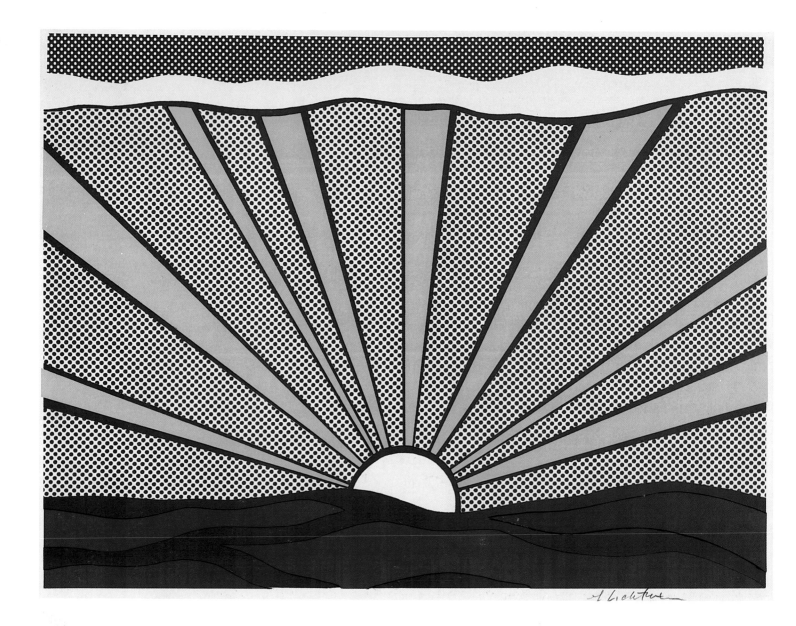

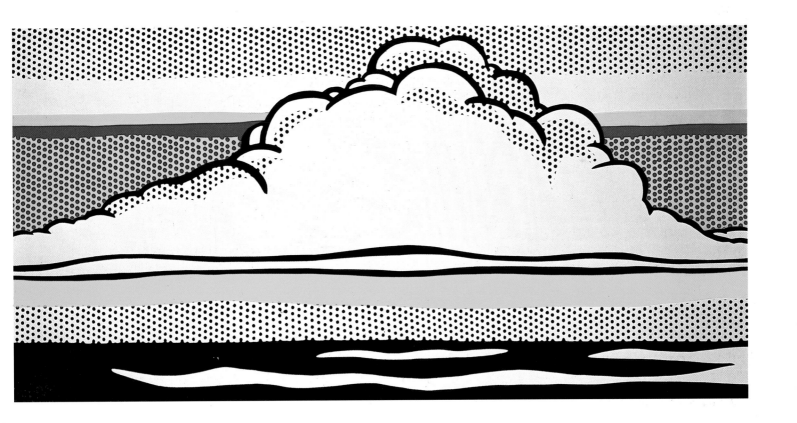

Cloud and Sea, 1964
Enamel on steel, 76 × 152.5 cm
Cologne, Museum Ludwig

late convert, took up the style. Apparently Lichtenstein was trying to connect with the mainstream art market. In 1959 he showed the new work in New York, but it received no notable attention. Yet if Lichtenstein had felt fully at ease with Abstract Expressionism, he probably would not have begun to make odd little drawings of comic strip figures such as Mickey Mouse, Donald Duck, Bugs Bunny and other Disney-style characters. He nested these comic characters into otherwise abstract expressionist surfaces. Once when asked by John Coplans what made him break with the past and begin to use cartoon characters he replied, "Desperation. There were no spaces left between Milton Resnick and Mike Goldberg (two second generation Abstract Expressionists)." Lichtenstein also says he was influenced by Willem de Kooning's *Woman* paintings, in which female figures or heads were embedded in expressive brushwork. His Mickeys and Donalds poked fun at de Kooning's anxious and rough erotic imagery. Still, Lichtenstein's first paintings using comic figures were never shown publicly and they were all destroyed or painted over. Only a few drawings remain from this period. Despite the artist's lack of confidence in these works, however, the transitional jump to Disney personalities was not at all out of keeping with Lichtenstein's previous paintings. He had always been interested in simple American mythological subject matter and he had also humorously transformed existing images into pictures of his own.

Lichtenstein's attraction to this kind of unconventional subject matter was reinforced by some of the things other artists were beginning to do. New influences began to make themselves felt in

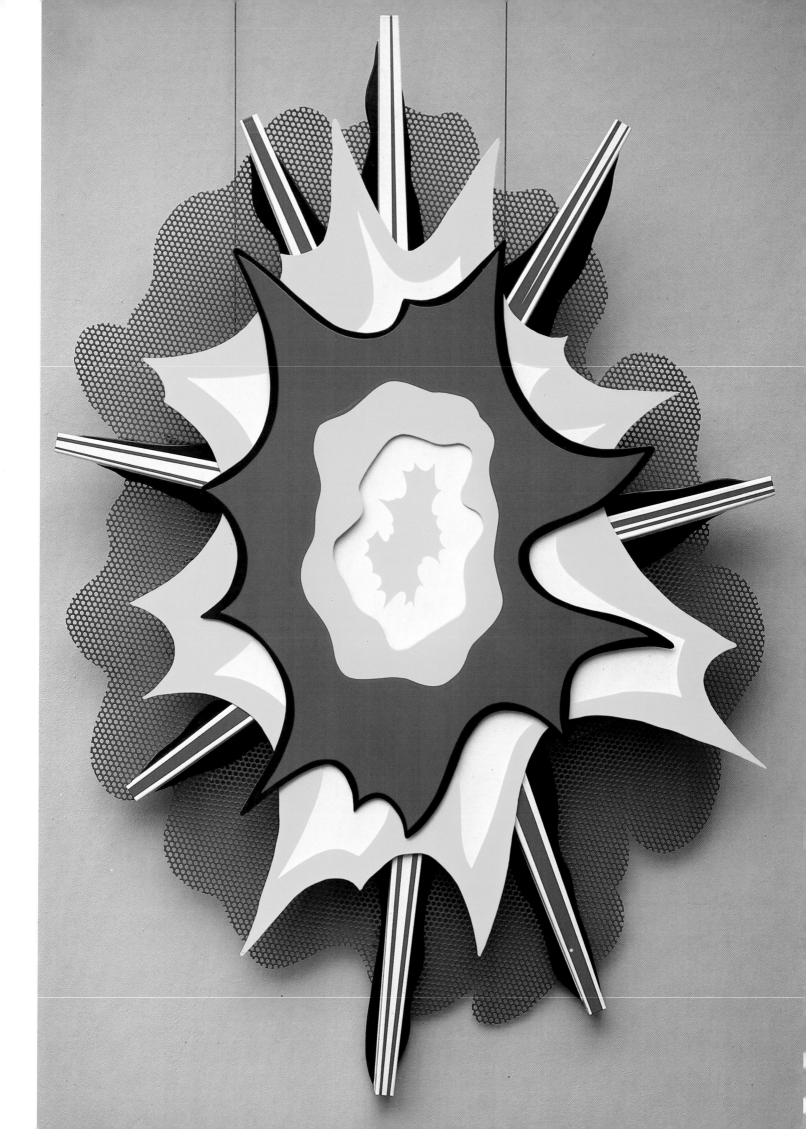

1960, after Lichtenstein began teaching at Douglass College, the women's branch of Rutgers University. (Rutgers is just south of New York City in New Jersey.) At that time, Rutgers had several innovative young artists on its faculty. Through them, Lichtenstein caught up on what had been developing in the City while he had been in Ohio and upstate New York. One important colleague at Rutgers was the artist and art historian Allan Kaprow. Kaprow had distanced himself from the conventional art object by creating environments and organizing happenings. For example, in Kaprow's environment at the Hansa Gallery in 1958 in New York, he created a confusing maze of slashed and painted colored fabric suspended from the ceiling, interspersed with sheets of plastic, cellophane, tangled adhesive tape and Christmas lights. Once every five hours electronic music issued from tape recorders placed about the gallery. The public was free to make its way through these anarchic surroundings. In his own art, Kaprow had further developed the ideas of his teacher, the musician John Cage. For Cage, commonplace things possessed aesthetic significance and the world itself was a work of art in which all things participated. Influenced by this train of thought, artists began to turn to everyday objects and situations for inspiration. Two Cage students that became influential were Robert Rauschenberg and Jasper Johns. Johns painted flags, numbers and targets such that critics were confused about whether or not they had art in front of them: "Is it a flag or is it a painting?" Robert Rauschenberg made "combine paintings" which brought found junk and brushstrokes together. By March 1958, both Rauschenberg and Kaprow were included in a *Newsweek* article called "Trend to the 'Anti-Art'". *Newsweek* called Kaprow a dangerous radical who threatened to overthrow traditional art values. Through their contact at Rutgers, Lichtenstein got to know Kaprow's work and he attended several Happenings. Lichtenstein has since said that Happenings, those amusing, thought-provoking theatrical events, were one of the largest influences on his work. His own irreverent side responded favorably to the anti-authoritarian, free-wheeling spirit of Kaprow's attack on art. It was this new atmosphere that set the stage for Lichtenstein's provocative comics.

Lichtenstein's two sons, born 1954 and 1956, were very young children when he began to make drawings of bubble gum wrappers at the end of the fifties; maybe their enjoyment of the imagery helped him realize just how immediate cartoon figures had become to American culture. As he once said in a discussion with Bruce Glaser, he was drawing little Mickey Mouses for his children. However, it was Kaprow who encouraged him to leave the comic image as it was, without painterly interference. As Lichtenstein explained to Glaser, "Then it occurred to me to do one of these bubble gum wrappers, as it is, large, just to see what it would look

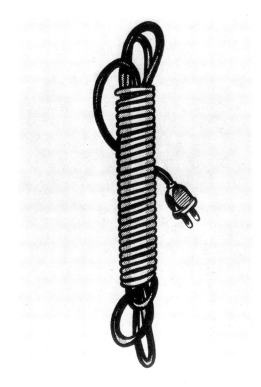

Electric Cord, 1961
Oil on canvas, 71.1 × 45.7 cm
New York, Mr. and Mrs. Leo Castelli

Explosion No. 1, 1965
Varnished Steel, 251 × 160 cm
Cologne, Museum Ludwig

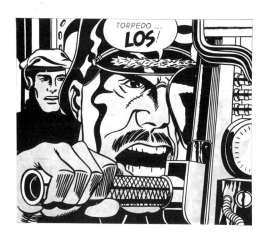

Torpedo . . . los!, 1963
Oil on canvas, 172.7 × 203.2 cm
Winetta (Il.), Collection Mr. and Mrs.
Robert B. Mayer

Shipboard Girl, 1965
Offset lithograph in red, blue, yellow and
black, 69.9 × 51.4 cm
Published by Leo Castelli Gallery, New
York

like. Now I think I started out more as an observer than as a painter, but, when I did one, about half way through the painting I got interested in it as a painting. So I started to go back to what I considered serious work because this thing was too strong for me. I began to realize that this was a more powerful thing than I had thought and it had interest."

The early Mickeys and Donalds were clearly executed by an artist's hand, but in 1961, Lichtenstein decided to make a complete break with the expressive idiom. Lichtenstein realized that a quotation of the actual industrial printing techniques and the inclusion of the text balloon both strengthened the image and added a baffling new quality. Was such a big comic to be considered art? The first large scale oil painting using hard-edged figures, industrial colors and the Benday dots used in commercial printing to achieve half-tones was *Look Mickey* (Ill. p. 11). It shows the emotional Donald Duck hooking his own coattail and getting excited about a big fish that will doubtless be the one that got away. Mickey, as always finer and smarter than Donald, is restraining his laughter with a gloved paw. There is no telling why Lichtenstein picked out this particular comic event, except that it does contain a punch line. Perhaps the scene appealed to him for formal or associative reasons. Perhaps Lichtenstein is making light of those emotional artists who fool themselves into thinking they're onto something grand and new in art. Donald's big expressive eyes are starting out of his head as if he really does see a fish, while the cooler Mickey, whose eyes are small and empty, knows better. Whatever its implications, *Look Mickey* started the ball rolling. Lichtenstein's style became the industrial style of the printed comic. In that same year, he painted about six works using recognizable characters from bubble gum wrappers or comic books. As with *Look Mickey,* he drew them directly onto the canvas with pencil and then painted them in with oil. Only minor changes were made from the original comic. (The pencil marks are clearly visible at points where Lichtenstein "corrected" his first sketch by changing proportions slightly during painting.) The Benday dots were suggested by an irregular network of fine dots applied to selected areas. In *Look Mickey* the dots show up on Donald's eyes and the mask of Mickey's face.

In some of Lichtenstein's early comics, the balloon texts seem to contain wry messages. Another painting from 1961, *Mr. Bellamy* (Ill. p. 12), is something of an inside joke. Dick Bellamy, director of the Green Gallery, was well-known for his recognition of new work. He was open to developments in the arts and often exhibited young, unknown artists for the first time. Lichtenstein's upright, young officer is thinking to himself a little apprehensively. (The unspoken quality of the text is indicated by the small bubbles leading to the balloon. This was the kind of symbolic punctuation

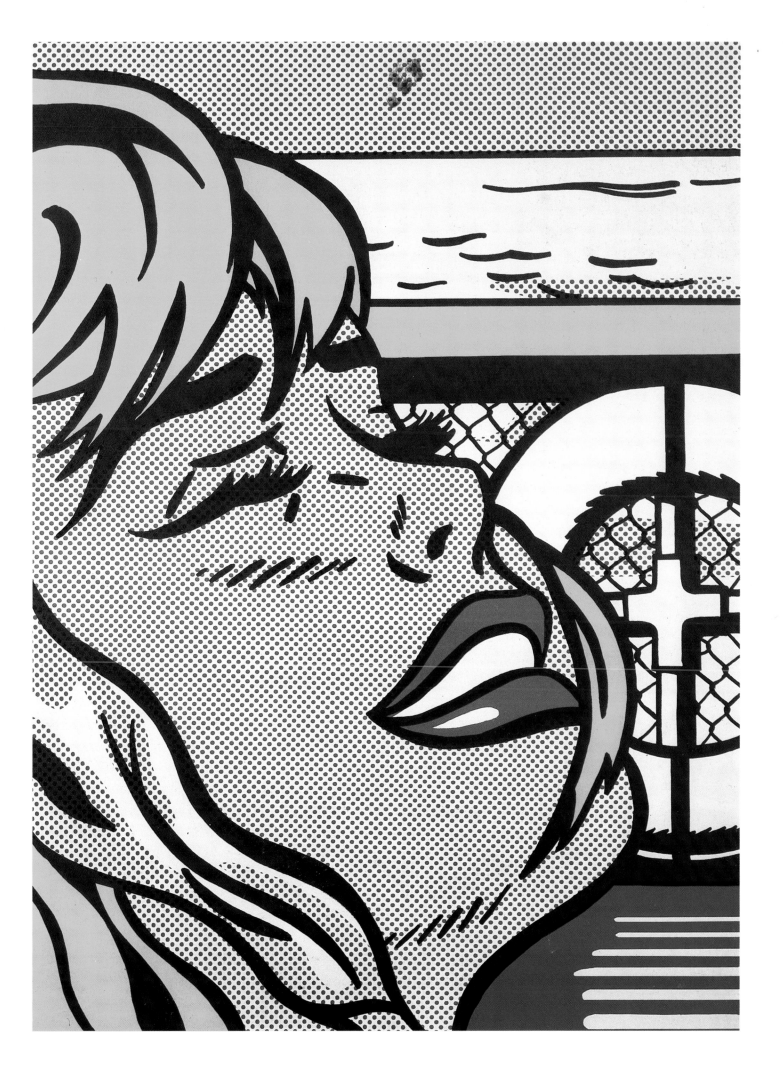

Source for Takka Takka

that Lichtenstein admired in the comics.) An unseen authority has issued an order and he dutifully obeys: "I am supposed to report to a Mr. Bellamy. I wonder what he's like." Here Lichtenstein is treating a career mission with irony. Perhaps he felt himself to be only one of a veritable army of artists with the uniform wish of finding a gallery as good as Dick Bellamy's to represent him.

Such were the paintings that Lichtenstein showed to Leo Castelli in the autumn of 1961. Castelli immediately accepted Lichtenstein's new work for his gallery. Only a few weeks later, Andy Warhol showed his own paintings using comic figures to Castelli. It is a telling coincidence that both Lichtenstein and Warhol should arrive at the same subject matter at the same time without being in the least acquainted with one another. But there was one important difference between the comics of the two artists: their styles. Warhol's paintings still retained expressionist brushwork. Castelli did not accept Warhol's work and Warhol recognized why. He knew that his comic figures were not as provocative as those of Lichtenstein, which led him to draw a swift conclusion: "I told Henry (Geldzahler) I was going to quit painting comic strips and he didn't think I should. Ivan (Karp) had just shown me Lichtenstein's Benday dots and I thought, 'Oh, why couldn't I have thought of that?' Right then I decided that since Roy was doing comics so well, that I would just stop comics altogether and go in other directions where I could come out first – like quantity and repetition. Henry said to me, 'Oh, but your comics are fabulous – they're not "better" or "worse" than Roy's – the world can use them both, they're both very different.' Later on, though, Henry realized, 'From the point of view of strategy and military installation, you were of course correct. That territory had been preempted.'"

Whaam, 1963
Magna on canvas, 172.7 × 406.4 cm
London, The Tate Gallery

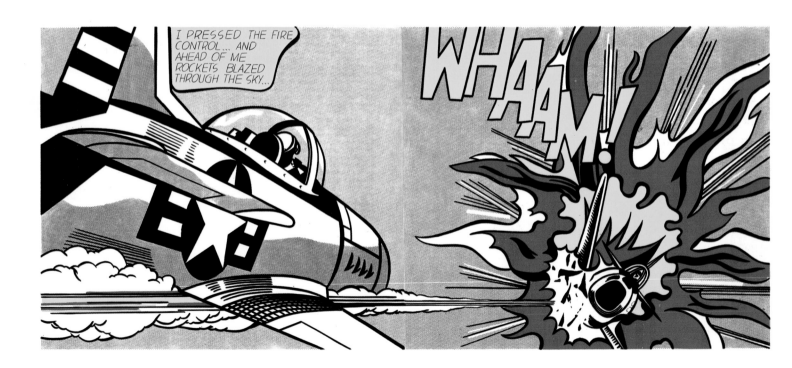

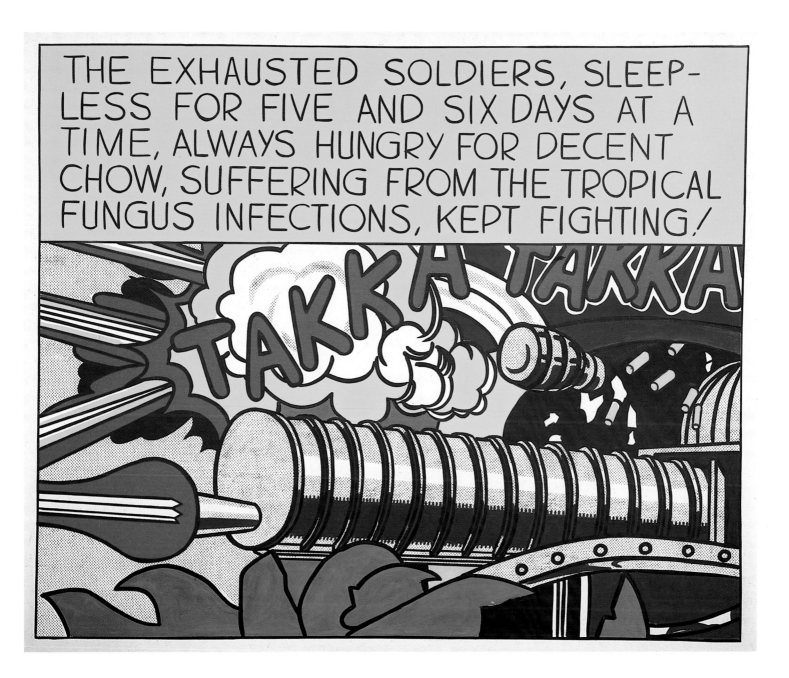

Indeed, Lichtenstein had found his artistic "territory" with the adoption, or better still, adaptation of printed subject matter. Lichtenstein dropped the Disney characters, which did not seem anonymous enough for his purposes. Similarly banal and discredited images, such as the small advertisements in the yellow pages, illustrations of items in mailorder catalogues, or the more adult-looking romance and war comics took their place. His first one-man show at Castelli's in February 1962 was bought out by influential collectors even before the opening. In *Masterpiece* (Ill. p. 14) (1962) Lichtenstein seems to be taking an ironic look at his new success. It finally appeared that he could live from his art instead of having to teach, and Lichtenstein withdrew to the life of a painter.

Takka Takka, 1962
Magna on canvas, 173 × 143 cm
Cologne, Museum Ludwig

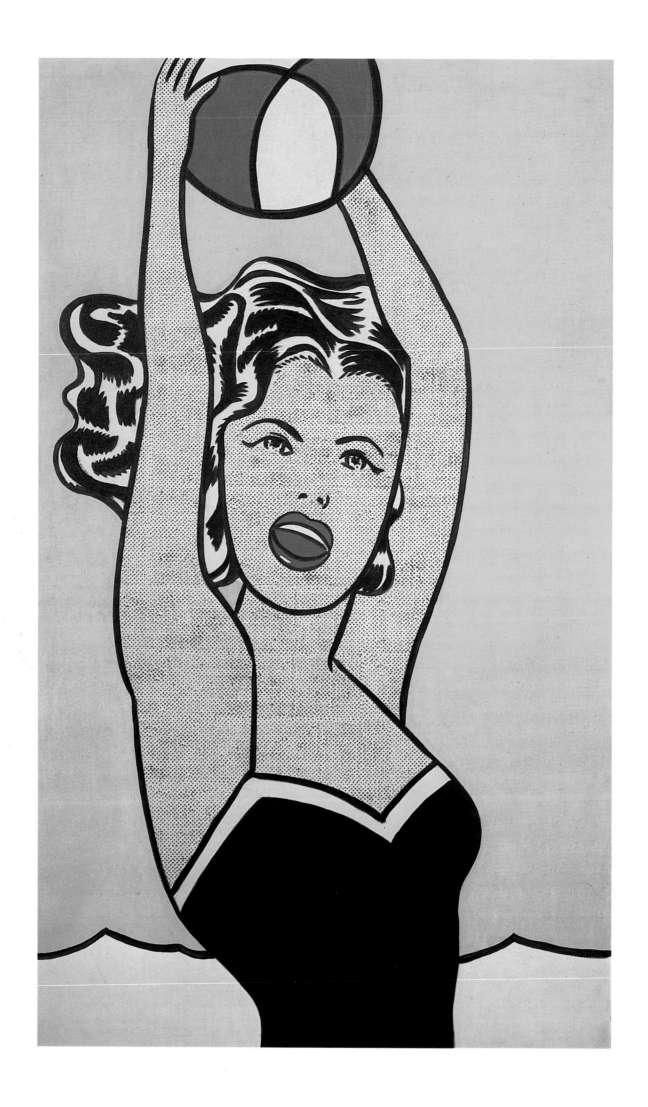

The Pictures that Lichtenstein Made Famous, or
The Pictures that Made Lichtenstein Famous

Lichtenstein has said that he wanted his images to look as machine-made as possible, but deep in his heart he remained a painter. Unlike Andy Warhol, he almost never took photography as a basis for his work. He preferred to use impersonal hand-drawn figures. For example, the teen and action comics behind such paintings as *M-maybe* and *As I Opened Fire* (Ill. p. 28/29) were images produced by teams of illustrators who left no personal elements of style behind. Small commercial drawings like those in the yellow pages had previously held no particular interest or value to an art public. Lichtenstein took them and turned them into large, disturbing presences such as *Head – Yellow and Black*. Tension is created between the look of an anonymous drawing style and the knowledge that an individual artist did actually execute a commercial image. A reminder of the human hand remains inherent to the drawing process itself, however impersonal it may seem. By presenting the lowest, most depraved form of art to a public attuned to high art, he focused on a moot point. As he said, "I'd always wanted to know the difference between a mark that was art and one that wasn't."

The early work is diverse in its choice of subject matter. A common denominator is the previously existing, two-dimensional reproduced state of whatever Lichtenstein chooses to show. In some cases the original image has been preserved or rediscovered, so that Lichtenstein's changes may still be observed. (Contrary to what most critics thought at the time, Lichtenstein did change the images he used considerably.) Many of the images, however, seem so point-blank and anonymous that it would be nearly impossible to identify them. *Golfball* (Ill. p. 26) (1962) shows just that. The small cusps and ellipses indicating the pores of its surface make it recognizable as a three-dimensional object, but they are also a play on abstract signs. For someone familiar with modern art, the formally related oval paintings of Piet Mondrian from before the First World War (Ill. p. 26) may come to mind. Yet there are also parallels with contemporary art. The simultaneous reduction of subject and infla-

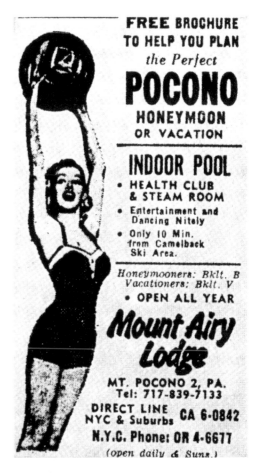

Extract from a Sunday Supplement of the "New York Times"

Girl with Ball, 1961
Oil on canvas, 153.7 × 92.7 cm
New York, The Museum of Modern Art

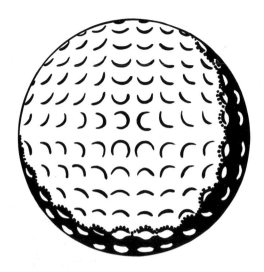

Golf Ball, 1962
Oil on canvas, 81.3 × 81.3 cm
Beverly Hills (Ca.), Collection Mr. and
Mrs. Melvin Hirsch

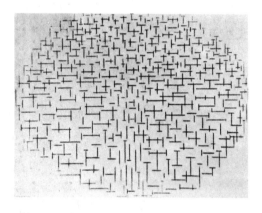

Piet Mondrian
Pier and ocean, 1915
Oil on canvas, 85 × 108 cm
Otterlo, Rijksmuseum Kröller-Müller

The Melody Haunts My Reverie, 1965
Silkscreen in red, blue, yellow, black,
69.9 × 51.4 cm
"11 Pop Artists" portfolio, Vol. III

tion of scale in *Golfball* shares the humorous effect of Claes Olden-burg's sculpture. Oldenburg's slices of cake, sandwiches or jeans made out of vinyl, plaster or fabric are unsentimental and matter-of-fact. The use or function of these things becomes dubious. Like Lichtenstein's *Golfball*, they are simply products whose insistent presence is not in the least diminished by their actual expendability. Indeed, one begins to doubt whether they are expendable at all.

The sixties were a time when almost any familiar object could be made "new and improved." Marketing strategists were con-stantly developing ways of presenting relatively unspectacular pro-ducts in a dramatic light. The products became symbolic of an ideal way of life. Lichtenstein may have been reacting to this post-war development in advertising when he started to draw and paint various kinds of consumer goods. The ridiculous side of advertis-ing's break with reality must have pleased him. *Roto Broil* (Ill. p. 8), *Washing Machine* (Ill. p. 15) and *The Couch* (all 1961), or *Chop*, *Refrigerator* and *Sock* (Ill. p. 7) (all 1962), are hard line drawings of things people need to be convinced to buy in order to lead a better life. Obviously they have been taken from mail-order catalogues or advertisements in newspapers, since they are isolated on white backgrounds as if on a page. Aside from an occasional brand name, there is no accompanying text, nor do the objects seem to contain unspoken messages as do the objects in Surrealist paintings. They share the mute frigidity of monuments, whose heroic assertions seldom allow the public to identify with them. Yet Lichtenstein is not criticizing consumer culture in these drawings. He is simply showing the way it is, and it ends up parodying itself.

A similarity between the comics and the consumer-goods drawings is their primitive strength, their concentrated visual appeal. In a way, his grasp of commercial art is analogous to the Cubists' recognition of African art as a source of authentic, strong imagery. Lichtenstein not only admired the direct force behind commercial art, he also appreciated the way the intent of the work was so efficiently expressed in its form. In an interview with Gene Swenson, Lichtenstein once commented that when he began to make his Pop images, almost anything was being accepted as art. Even work showing no apparent discipline or thought in its execu-tion, like "a dripping paint rag", was being shown. This art was bad, but it was created in an artistic spirit, a spirit that saw itself as an independent genius. Commercial art was shunned by such "fine" artists, who would have rather felt themselves indebted to an inspir-ing muse than employed by a paying company. For example, when Robert Rauschenberg and Jasper Johns decorated department store windows in the early days for money, they used a pseudonym. Andy Warhol, who had been a prize-winning commercial artist, was not taken seriously at first because of this success. The intellec-

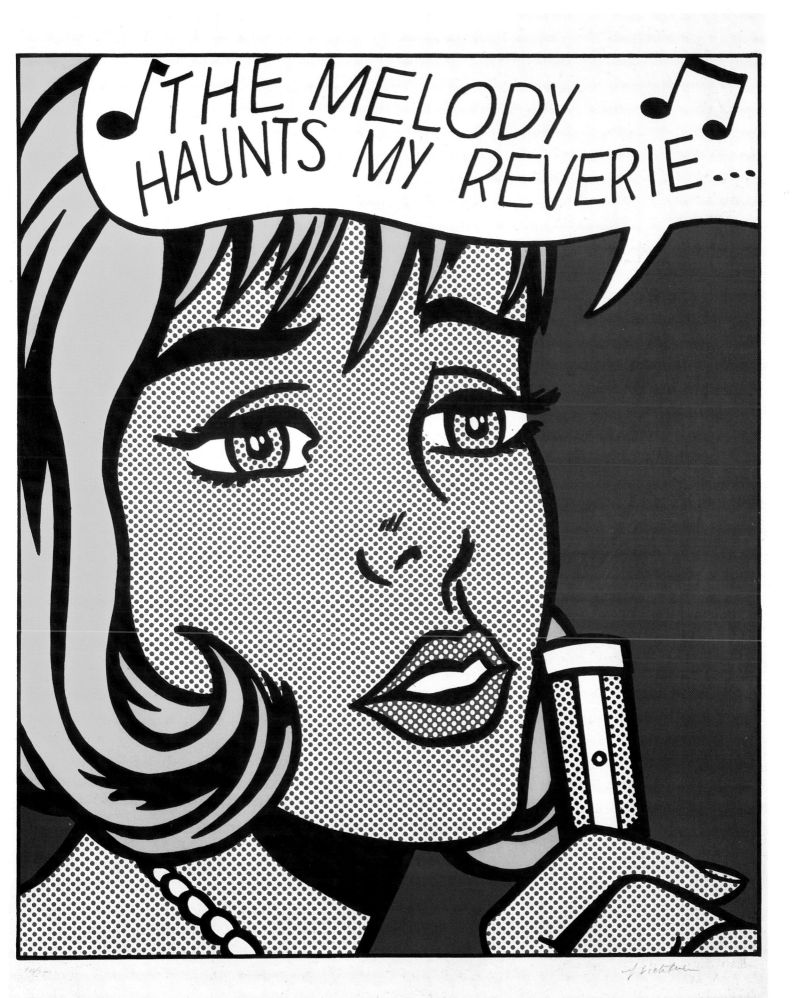

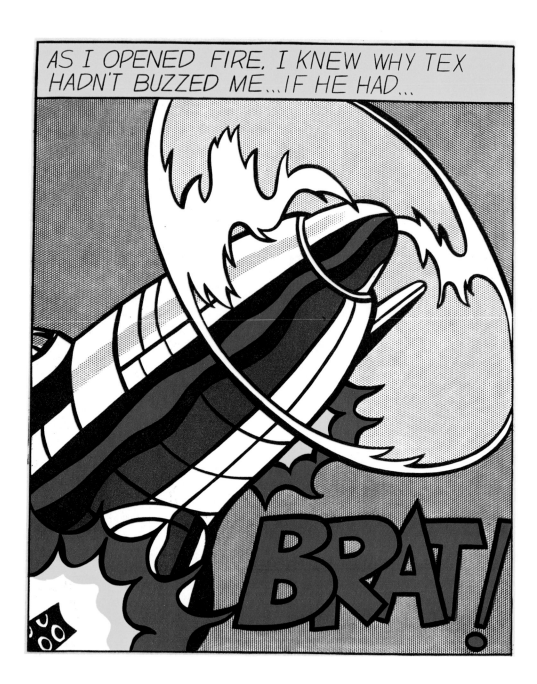

As I opened Fire, 1964
Magna on canvas, three panels,
172.7 × 142.2 cm
Amsterdam, Stedelijk Museum

tual art public looked down on artists who did whatever a company wanted for money, since it seemed to exclude artistic inspiration and thought. Its unacceptability was what made commercial art a perfect avantgarde weapon against the established highbrow order of the time. Lichtenstein was the first to recognize the high quality of much commercial art. Other artists had used everyday subject matter or materials in their work, but Lichtenstein went one step further and cited actual commercial processes of depiction and reproduction. He broke through the traditional barrier of definition and crossed over into dangerous territory. In contrast to Castelli's foresighted collectors, most of the major critics reacted angrily against his work.

Still, Lichtenstein did not exactly support the cause of commercial art, even if he admired certain aspects of it. Pop Art is not

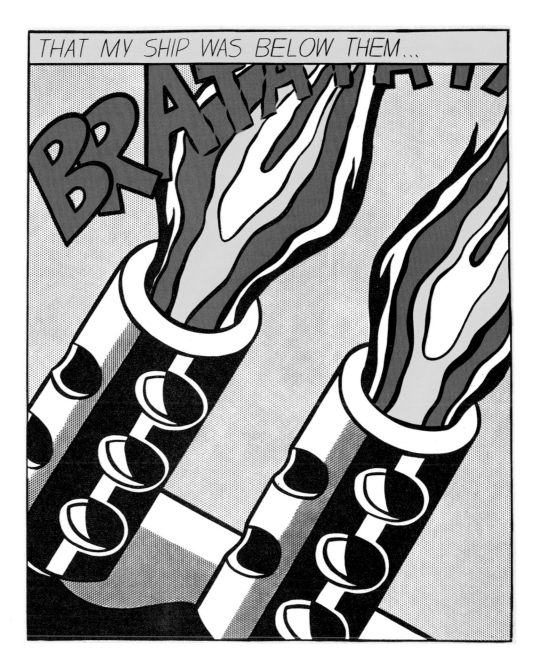

affirmative as much as diagnostic. For example, when Lichtenstein brings truncated parts of human anatomies into play with consumer objects, the viewer does not feel herself or himself "being sold" a new idea. One such especially funny image is the double-panel work, *Step-on Can with Leg* (Ill. p. 30) (1961), which might well be taken from a graphic instructions sheet that came with a new waste can. A petite female lower leg enters the picture at a diagonal from the left. A checked skirt – the checks do not behave as if they were printed on soft material – primly covers the knee, while the dainty high heeled shoe – not at all appropriate for housework – reaches out for the can pedal. The »story« continues on the second panel, which seems at first to be merely a repetition of the first. Yet a barely distinguishable pressure of the ladylike foot brings about the result: an opened can where garbage or diapers may disappear. The flowers

"A minor purpose of my war paintings is to put military aggressiveness in an absurd light. My personal opinion is that much of our foreign policy has been unbelievably terrifying, but this is not what my work is about and I don't want to capitalize on this popular position. My work is more about our American definition of images and visual communication."

ROY LICHTENSTEIN

29

decorating the can suggest an industrially achieved hygienic fresh-
ness, most in keeping with the idea that it is no longer necessary to
come into actual contact with a waste can in order to open it. The
pretty artifice and mannered daintiness of the situation is absurd.
The main actor, one finally realizes, is not the woman who is
attached to the leg, but the little waste can she is being used to
demonstrate. Several of Lichtenstein's early works ironically deal
with the way women are used as an extension of the household
appliance. It was a theme that the English Pop artist Richard Hamilton
had already touched upon in his epoch-making collage, *Just What Is
It That Makes Today's Homes So Different, So Appealing?* (1956).

A daily newspaper advertisement for a honeymoon hotel in the
Poconos (Ill. p. 25) gave Lichtenstein the idea for his *Girl with Ball*
(Ill. p. 24) (1961). She was the kind of girl whose snapshot Mr.
Bellamy's young officer would have carried around in his wallet.
Both the advertisement and the painting show the cliché of a beauti-
ful young woman with waves of shiny hair, parted red lips, a great
figure and shaved armpits, holding a beach ball up over her head.
She must be "having a ball", because why else would her whole
body be involved in the abandoned movement – frozen here – of
playing with one? Yet Lichtenstein has somehow drained the sup-
posed fun out of the Poconos image. The painting concentrates on
the girl's gesture, which is communicated by only the upper portion
of her body. While the advertisement is very small, Lichtenstein has

Step-on Can with Leg, 1961
Two panels, oil on canvas, 82.5 × 134.6 cm
London, Collection Robert Fraser

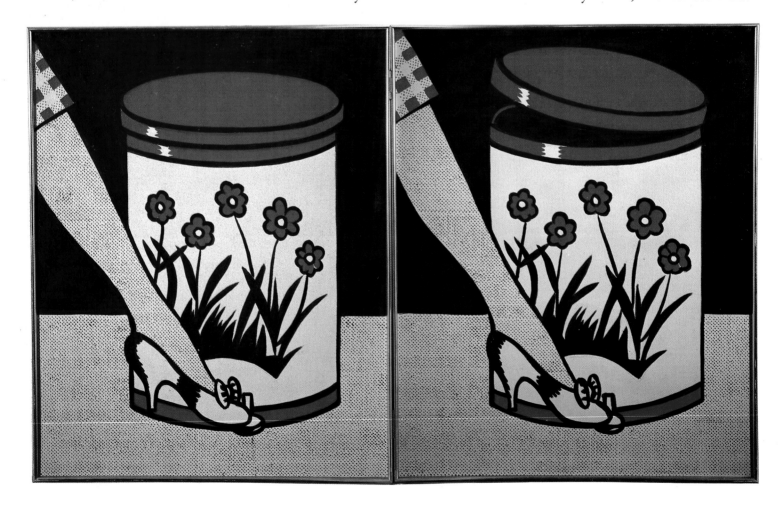

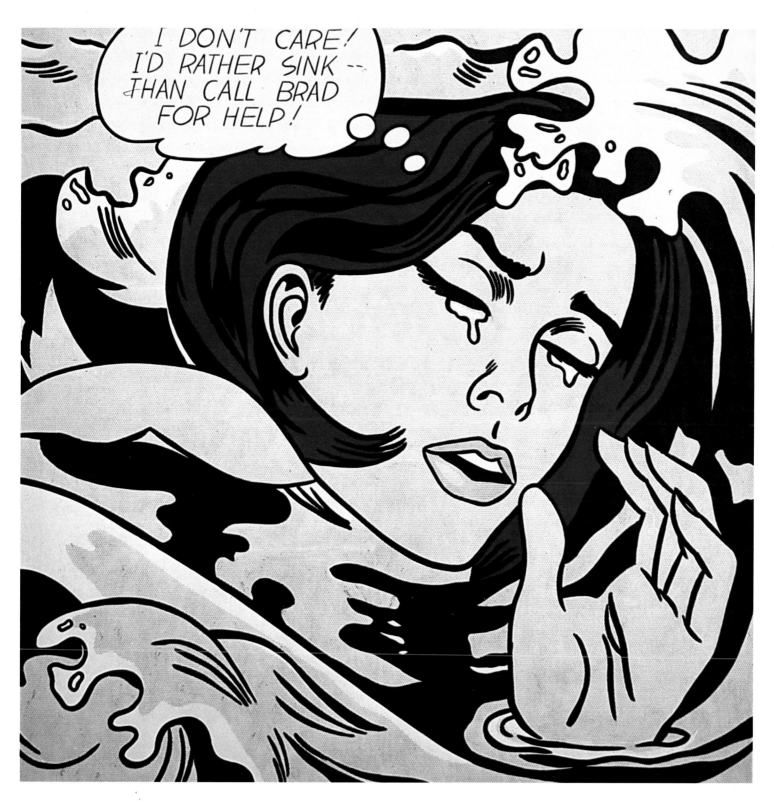

blown the girl up to over life-size. The limited use of colors dissects and further simplifies the primitive effectiveness of the original black and white image. Just as in a cheaply printed comic, where few colors must fulfill different functions, here, too, Lichtenstein depends on a color-use dictated by "economy". The girl's hair is as blue as her bathing suit, recalling the way commercial printers often saved an extra color printing. (Even though there is no such thing as blue hair, it is quite clear that dark hair is meant.) Again, it is one of Lichtenstein's humorous touches to have made referential use of an economical principle. Its logic has disappeared. After all, he is

Drowning Girl, 1963
Oil and magna on canvas, 171.8 × 169.5 cm
New York, The Museum of Modern Art

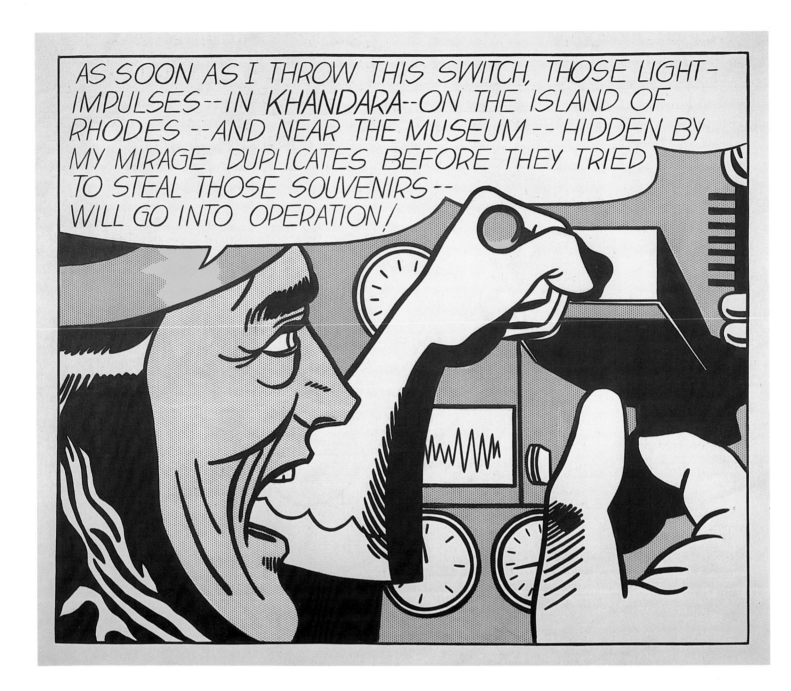

Mad Scientist, 1963
Magna on canvas, 127 × 151 cm
Cologne, Museum Ludwig

painting and not printing his image. In another detail, a shared color sets up a nonsensical relationship, also not without its humor. The girl's parted red lips reveal a white strip designating pearly teeth and making her curiously tipped mouth resemble the crescents of her red and white beach ball. The white stripe of her bathing suit, the light reflections on her hair and finally the silhouette of waves behind her continue this play on forms. In *Girl with Ball*, Lichtenstein is not only presenting a clichéd image. He is also interested in the way abstract shapes can be manipulated to signal certain associative meanings. Certainly these shapes have their ambiguities. They spring back and forth between design of the two-dimensional surface and the denotation of the actual figure shown. Lichtenstein insisted that the formal aspect of his painting was more important than generally realized. His compositions were at least as carefully considered as his choice of subject matter.

out of his painted oeuvre. Although a piece like *Standing Explosion* (1965) works with perforated steel to show dots in a negative way, positive dots were impossible in sculpture since they could not float in free space. In his *Cup and Saucer* (Ill. p. 60) sculptures, his *Expressionist Head* or his Matissean *Goldfish Bowl* (Ill. p. 61) series, the shading effect of the diagonals emphasizes the linear quality of the sculpture as a whole. These sculptures rather astound one, since they seem to have fallen off a page into reality. The *Lamp* sculptures with their sturdy rays of light, or the large outdoor *Mermaid*, who is being beamed at day and night by the sun, irritate the viewer with the way their two-dimensional ancestry contradicts their three-dimensional presence.

After Lichtenstein had used his style for about five years, it seemed to change under his hands and take on new directions. Gradually, different kinds of surface patterning became important. The meaning of the Benday patterning changed from being a symbol of a color printing process into an abstract structure or a decorative tool. A series of *Trompe l'Œil* (Ill. p. 50) paintings have woodgrain backgrounds that are not only an allusion to traditional American trompe l'oeil artists, but also a new way of decoratively dealing with the two-dimensional surface of the canvas. The grains of wood are visually related to the diagonal lines that took the place of dots. In other paintings Lichtenstein began to grade the sizes of his Benday dots, thus keeping step with real form developments in comic art. The dots decrease in size as they continue on in rows, thus seeming to fade away or sink into a theoretically deeper level of space. The *Mirrors* (Ill. p. 75–79) and *Entablatures* (Ill. p. 80) in particular use the dots in this way. Gradated dots may also enliven the surface of a painting by seeming to swirl or radiate in undulating patterns, as in *Forest Scene* (Ill. p. 69) (1980), which is reminiscent of a painting by the German Expressionist Franz Marc. *Forest Scene* even contains some fields with actual visible brushstrokes as a sort of reverse Benday dot shading. In such late paintings it seems that Lichtenstein is allowing a small caged corner of Expressionism back into his art.

After looking at so many dots or patterns and considering their use, the viewer may feel that he or she knows what Lichtenstein is doing with them, which is more than Lichtenstein has admitted to knowing for sure himself. In an interview with John Coplans in 1970 he said, "Anyway, the dots can have a purely decorative meaning, or they can mean an industrial way of extending the color, or data information, or finally, that the image is a fake. A Mondrian with a set of dots is obviously a fake Mondrian. I think those are the meanings the dots have taken on, but I'm not really sure if I haven't made all this up."

"One would hardly look at my work and think it wasn't satirical, I think, or that it makes no comment... I'm not really sure what social message my art carries, if any. And I don't really want it to carry one. I'm not interested in the subject matter to try to teach society anything, or to try to better our world in any way."
ROY LICHTENSTEIN

49

Lichtenstein Looks at Art

In a way Lichtenstein always seemed to be considering all of art when he made a painting, thinking about what art was, what it did, who it did it for when and whether or not he wanted it. There were two ways in which he expressed this artistic self-consciousness. The first was referential and associative (Hokusai's wave in *Drowning Girl* or Mondrian's oval compositions in *Golf Ball* (Ill. p. 26)), while the second looked more like a direct appropriation of some other artist's work (Gilbert Stuart's portrait of George Washington, as presented in a Hungarian newspaper). This obsession with works of art is the leitmotif that runs through Lichtenstein's oeuvre from its very beginnings in Cubist versions of Remington western scenes.

It was almost impossible for Lichtenstein to look at art with the reverence accorded to it by the educated middle class. Its aura was a balloon of hot air that Lichtenstein could not resist pricking. The removed, cool banality of his comic and advertising images were an insult to the very institution of art, traditionally linked as it was to things intellectual and spiritual. The large painting *Art* (Ill. right) (1962) was a sign to hang on the wall, proof positive that its owner was indeed a collector, a person of culture. What had art turned into if not a commodity, a symbol of the collecting class, an incestuous aesthetic love affair freighted with metaphysical implications? As an institution, art deserved to be put back in touch with reality in the form of popular culture. As happening artist and art historian Allan Kaprow said, "A walk down 14th Street is more amazing than any masterpiece of art."

In the following anecdote related by Kaprow, the avantgarde's gut rejection of fine art at this time becomes clear. One day, Kaprow and his family were visiting the Lichtensteins at home. While the artists' wives and children left in the car to get some refreshments, the two men talked about their work. Kaprow's anecdote is interesting enough to cite at length: ". . . Roy and I started to talk about teaching – how to teach students about color. Roy was very caught

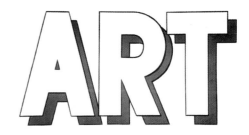

Art, 1962
Oil on canvas, 91.4 × 172.7 cm
Minneapolis (MN.), Collection Gordon Locksley

Trompe-l'œil with Léger Head and Paintbrush, 1973
Magna on canvas, 116.8 × 91.4 cm
Private collection

Portrait of Madame Cézanne, 1962
Magna on canvas, 172.7 × 142.2 cm
Los Angeles (Ca.), Collection Mr. Irving
Blum

Still Life with Lemons, 1975
Acrylic on canvas, 228.5 × 152.5 cm
Aachen, Neue Galerie-Sammlung Ludwig

up with Cézanne then. The car came back, and the kids all had sticks of Bazooka Double Bubble Gum, the kind that had comics printed on the wrapper. I pulled one of those wrappers out flat, and I remember saying to Roy, sort of archly, 'You cant't teach color from Cézanne, you can only teach it from something like this.' He looked at me with the funniest grin on his face. 'Come with me', he said. I followed him upstairs to his studio, which was on the second floor of the house. He lifted up alot of abstract canvases that were tacked to the wall and showed me one at the back, which was an abstract painting with Donald Duck in it. I was sort of nonplussed at first. Two seconds later I let out a big guffaw. It was as though he confirmed what I'd just been saying."

Unlike Kaprow, Lichtenstein was capable of talking and thinking about the value of both Cézanne and the bubble gum wrapper as sources for modern art at the same time. Of course, Lichtenstein, who does not particularly like to travel around to museums, was not working from the original paintings anyway. He knew artists like Cézanne and Picasso mainly through reproductions, which theoretically brought them down to the level of "printed matter". They were "famous" artists who functioned as paradigms for the avantgarde: after meeting with initial outrage and rejection, both Cézanne and Picasso were understood as pioneers of abstraction (although what they were really trying for was a more true way of showing reality). Modern art was bound up with their names, as well as those of Mondrian, Matisse and Léger, some of whose works Lichtenstein would later re-make into his own. Apparently it was important to Lichtenstein to work with the "giants" of modernism, who, through their reproduction on art calendars and postcards, had become trademark styles or clichés in their own right. The art historical stature of these artists made Lichtenstein's ironic appropriation all the more effective.

Yet when talking about the reasons for choosing certain artists' work to transform, Lichtenstein has also emphasized the formal affinities that existed between his style and that of the artists in question. For example, the preference of clear, unbroken colors and the outlining of forms with black were characteristic of Léger, Matisse, Picasso and Mondrian at some time during their long careers. Lichtenstein works both with and against the styles of the artists he appropriates. And he is not so much aiming at particular paintings as at particular styles.

Kaprow's bubble gum wrapper anecdote also sheds some light on two paintings that Lichtenstein executed in 1962 and which both use Cézanne works as their starting points. In *Portrait of Madame Cézanne* (Ill. p. 52), Lichtenstein began as usual with a reproduction, this time from a book about Cézanne. Erle Loran, the author, had attempted to dissect the portrait of Madame Cézanne by using

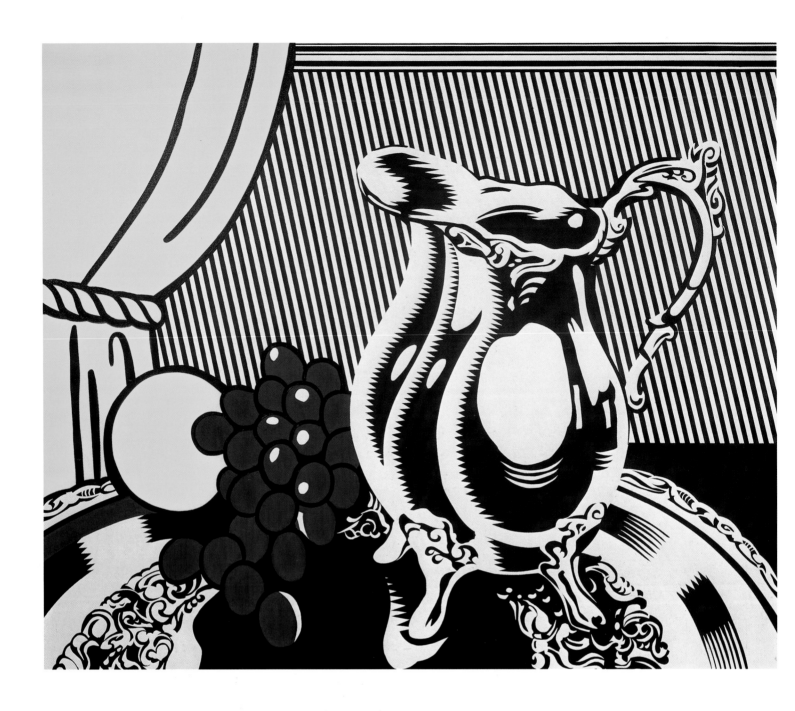

Still Life with Silver Pitcher, 1972
Oil and magna on canvas, 129.5 × 152.4 cm
Seattle (WA), Collection Mr. and Mrs.
Bageley Wright

an analytic diagram – this was a recognized art historical method at the time. Loran redrew the outlines of the painting's figure, and used small alphabetized arrows to signify areas and directions. The arrows were supposed to be an aid in analyzing the balances and counter-balances intended by the artist. Although diagrams like this could be confusing, they were meant to be scholarly. Lichtenstein, who often consulted art historical literature, must have been amused by the diagram, which wrestled with the positioning of the various body parts while ignoring the portrait's actual painted surface. This is strange since the way Cézanne broke up his painted surfaces into structural units was so important to the history of art. Picasso had studied the late Cézanne intensely and developed Cubism out of those paintings. (After looking at the Benday dots more closely, it becomes clear that Lichtenstein's response to Cézanne's work may even have something to do with his own patterned surfaces.) Con-

trary to both visual and art historical common sense, Loran had given Madame Cézanne an outline as definite as that of Lichtenstein's comic figures. In a way, Loran, who unsuccessfully tried to sue the artist, had made a cartoon out of Madame Cézanne, and Lichtenstein recognized the affinity to his own work:

"The Cézanne is such a complex painting. Taking an outline and calling it 'Madame Cézanne' is in itself humorous, particularly the idea of diagramming a Cézanne when Cézanne said, 'the outline escaped me'. There is nothing wrong with making outlines of paintings. I wasn't trying to berate Erle Loran, because when you talk about paintings you have to do something, but it is such an oversimplification trying to explain a painting by A, B, C, and arrows and so forth. I am equally guilty of this. *The Man With Folded Arms* (also taken from Loran's book) is still recognizable as a Cézanne in spite of the fact it is a complete oversimplification. Cartoons are really meant for communication. You can use the same forms, almost, for a work of art."

In 1962 Lichtenstein reworked a Cubist painting of Picasso in his *Femme au Chapeau* (Ill. p. 58), where the background vibrates with Benday dots and the woman's bosom swells like the palpitating breasts of the girls in the teen comics. At first one may be tempted to see this change as a caricature of Picasso's painting; some critics have

ILLUSTRATION PAGE 56:
Still Life with Figure, 1973
Oil and magna on canvas, 101.6 × 77.5 cm
Cologne, Museum Ludwig

ILLUSTRATION PAGE 57:
Interior with Cactus, 1978
Oil and magna on canvas, 72 × 60 cm
Saarbrücken, Saarland Museum

Still Life with net, shell, rope and pulley, 1972
Oil and magna on canvas, 152 × 234.5 cm
Cologne, Museum Ludwig

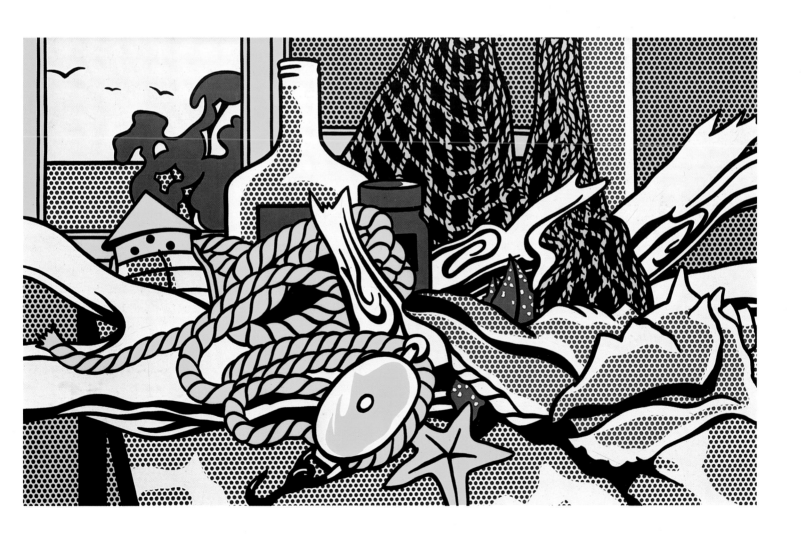

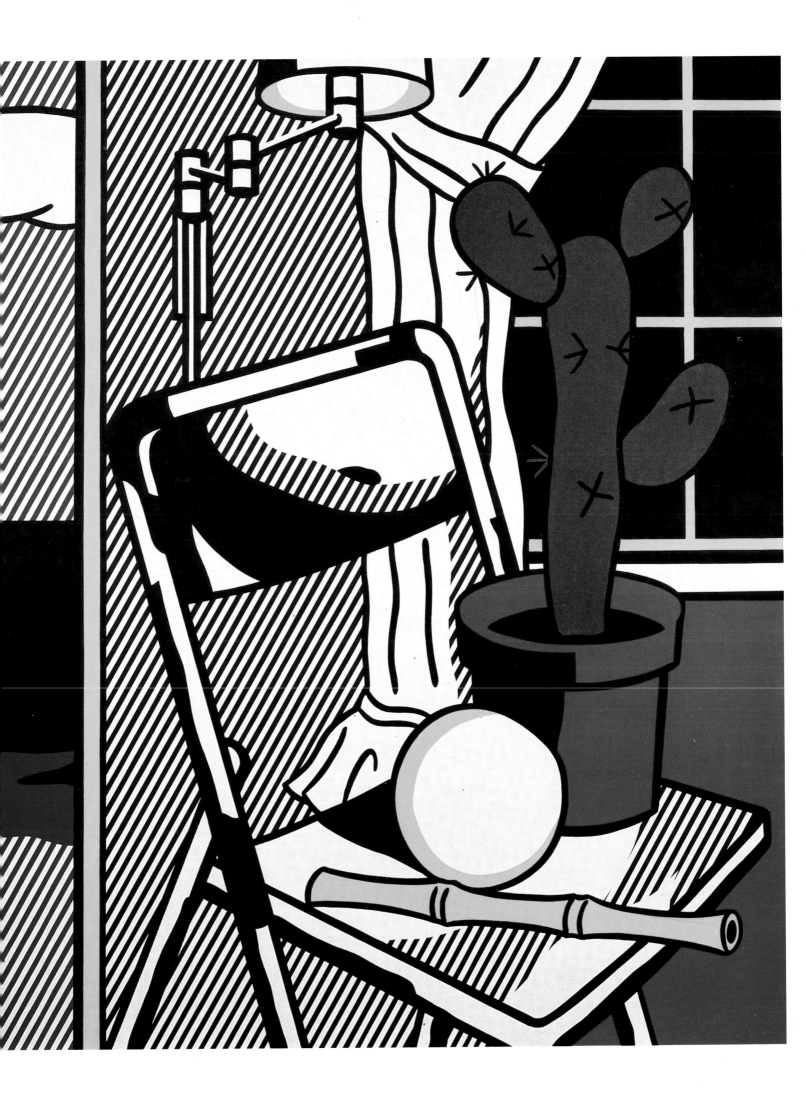

interpreted the transformation in this way. However, if Lichtenstein's changes are looked at carefully, this interpretation does not hold. The colors have been clarified and reduced to a primary blue and yellow, the shapes simplified and all given the same compositional weight. Lichtenstein has married his style to Picasso's existing forms, adapting the composition to his own purposes. What results is something entirely new that no longer has anything to do with the historical situation of Cubism. The change is analogous to the way a developing culture may try to recreate a superior culture's attainments, thus giving birth to new hybrids that have equal chances of becoming beautiful or grotesque. "It's a kind of 'plain-pipe racks Picasso' I want to do – one that looks misunderstood and yet has its own validity."

Femme d'Algier, 1963
Oil on canvas, 203.2 × 172.7 cm
New York, Collection Mr. and Mrs. Peter Brant

But why should Lichtenstein apply cartoon forms to Picasso? There are the obvious formal attractions for Lichtenstein, such as Picasso's outlining of forms in black and his reduction of a figure to flat shapes. But there was also a reason that applied to Picasso's status as an artist, which means Lichtenstein did not use a particular painting for its meaning as much as he used Picasso himself. As Lichtenstein reports, by the beginning of the sixties, the name Picasso had become a household word, the artist a popular hero: "one has the feeling there should be a reproduction of Picasso in every home." Lichtenstein is responding to the genius of the museum book and cardshop. When he transforms another artist's work, Lichtenstein is following an established tradition that was not always a form of respect for the elder artist, as can be seen in Picasso's rephrasing of an artist like Velázquez. Lichtenstein is aware of the added irony this brings about in his *Femme d'Algier* (Ill. p. 59) (1963): "Picasso made the 'Femme d'Algier' from Delacroix's painting, and then I did my painting from his." However, Picasso's image has again been radically transformed, and Lichtenstein's transformation looks about as much like the original as a woodgrain-formica table top resembles its oak prototype. There are many questions implied by such an adaptation of other artists' work; the viewer may ponder ideas of value, pretense, recognizability, style and originality.

Modern paintings more overtly concerned with the impact of the industrial revolution on the arts do not undergo quite such a physical shock when submitted to Lichtenstein's touch. *Non-Objective I*, for example, obviously a new version of a work by the Dutch constructivist Piet Mondrian, simply uses black Benday dots on the white background to create the gray fields Mondrian would have wanted. The industrial quality Lichtenstein strove for was inherent in early abstract art such as it was formulated by the "De Stijl" group of artists in Holland during the twenties. At first glance, the original painting cannot be made any more objective and cool

Femme au Chapeau, 1962
Oil and magna on canvas, 173 × 142.2 cm
Meriden (CT), Collection Mr. and Mrs. Burton Tremaine

Cup and Saucer II, 1977
Painted bronze, 111.1 × 64.1 × 25.4 cm
Edition: three copies
Private collection

than it already is. Yet seen from today's vantage point, both Mondrian and Lichtenstein share the same inconsistency. Their work, when experienced at a fairly close distance in a museum instead of as a reproduction in a book, can look touchingly inexact and human, despite all ambitions to the contrary. Pencil lines, small corrections or uneven painted lines betray the artist's hand at work.

Still, Lichtenstein satirized the artist's intentional expressiveness in many of his paintings, as in *Compositions* (Ill. p. 62) (1964). At first the large notebook cover appears to be another of Lichtenstein's object paintings. (There are several versions of this painting.) It fills the entire canvas in a way remininscent of the ten dollar bill, while the inherently abstract surface of the golf ball may also come to mind. Yet his use of the composition notebook is more complex. It is a humorous and intelligent allusion to a specific art style, as well as an everyday object. First of all, the kind of composition notebook he used was one that almost all American school children have "composed" in at one time or another. The black squiggles on its cover are an industrial version of a hand-marbled paper surface. Yet the all-over design and even the given black and white of the notebook cover are uncomfortably close to some of Jackson Pollock's dripped canvas surfaces, except that the latter Abstract Expressionist images are not rigid and industrial in nature. It is as if the notebook readymade had done Lichtenstein's work for him, reducing and hardening Pollack's image. The word "compositions" humorously sums up what a painter spends his time making. It may also remind us that the formal aspects of a painting – the artist's distribution of shapes and colors as well as his technique – are more important than its subject matter in determining its success as a memorable image. At the same time, the word *Compositions*, suggesting as it does conscious, controlled aesthetic decisions, does not quite seem appropriate to Pollock's dripped and splattered Action Painting method.

By the time Lichtenstein had started his career as an artist, the way a painting was executed was perhaps its most talked about property. Various forms of Abstract Expressionism had dominated the New York art scene since the early fifties. It was quite a shock for the Abstract Expressionists and their championing critics to fall from favor so rapidly after 1961. Pop, which seemed comparatively anonymous and machine-like, was recognized as the more challenging, more contemporary direction in the arts. All the meaningful expressiveness of gestural painting was out.

Lichtenstein's series of brushstroke paintings must be seen in this context, even though they were begun in 1965. The idea actually began with the comic image of a mad scientist who was crossing out the face of a haunting fiend with a big "x"-shaped brushstroke. Eventually, the brushstroke itself was isolated as a subject. As

Goldfish Bowl II, 1978
Painted cast, 73.7 × 64.1 × 28.6 cm
Edition: three copies

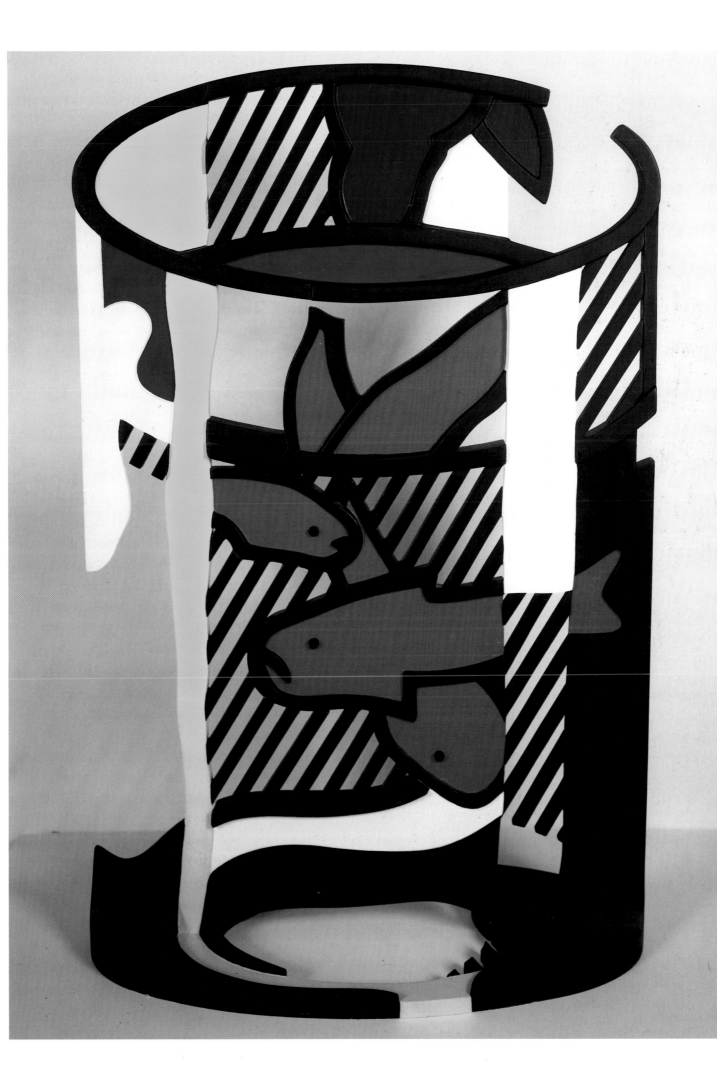

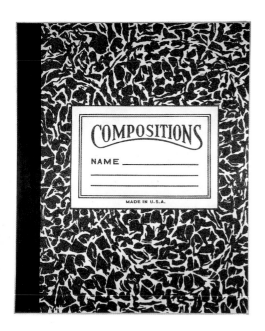

Compositions I, 1964
Oil and magna on canvas, 172.7 × 142.2 cm
Frankfort, Museum für Moderne Kunst

Lichtenstein once said in a interview, "... I developed a form for it, which is what I am trying to do in the explosions, airplanes, and people – that is, to get a standardized thing – a stamp or image. The brushstroke was particularly difficult. I got the idea very early because of the Mondrian and Picasso paintings, which inevitably led to the idea of a de Kooning." De Kooning, like Jackson Pollock, was a symbolic figure who embodied Abstract Expressionism as a style. This is what made him similar to Picasso and Mondrian, who were both linked to styles of their own.

Lichtenstein arrived at the brushstroke form by tracing the real thing: brushes loaded with paint were applied to an acetate film in strokes. After they had dried, one or more such brushstrokes could be projected onto a canvas, then drawn and painted in. The brushstrokes pretend to be spontaneous applications of paint that even drip down the canvas surface. Strangely enough, hard edges define the streaks that individual groups of brush hairs are supposed to have made; the drips are outlined. Benday dots objectively fill out the canvas behind the brushstroke, curiously separating it from the background upon which it has been painted. Lichtenstein has freeze-dried the sensual material of paint, as if he were eliminating the handmade quality of paintings once and for all. The monumental scale of the petrified brushstrokes makes them into memorials commemorating the heroic medium of painting which literally had fallen in Action.

Although Lichtenstein ought to have been appreciative of artists who, like himself, attempted to bring art's forms down to a clear, industrial minimum, he didn't identify with those who felt themselves to be the creators of a new classicism. This judgment has its roots in Lichtenstein's underlying anti-elitist stance. He didn't feel that classic modernism, brought to the United States from Europe during the thirties, was at all typical of American society: "Our architecture is not (Mies) van der Rohe, it's really McDonald's, or little boxes."

From the turn of the century on, "modern" movements had come into life in almost all countries that either were heavily industrialized, or that wanted to be, and most of these movements were dogmatic to the point of seeming misguided or even humorous today. (One of the artists Lichtenstein saw fit to cite, Mondrian, believed that his abstract art using horizontals and verticals perfectly expressed true beauty and universal harmony. When his colleague, van Doesburg, began to use diagonal abstract forms in 1925, Mondrian declared these compositions to be subjective and personal and left the De Stijl movement.) The bravura of much of this modern art of the twenties and thirties depended to a great extent on its identification with the machine age and the human freedom which machines were believed to make possible. Indeed, a spiritual idealism

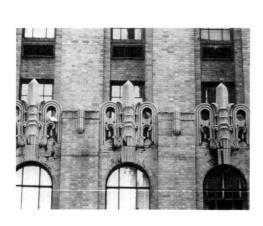

Art Deco ornament
Panhellenic Tower, New York

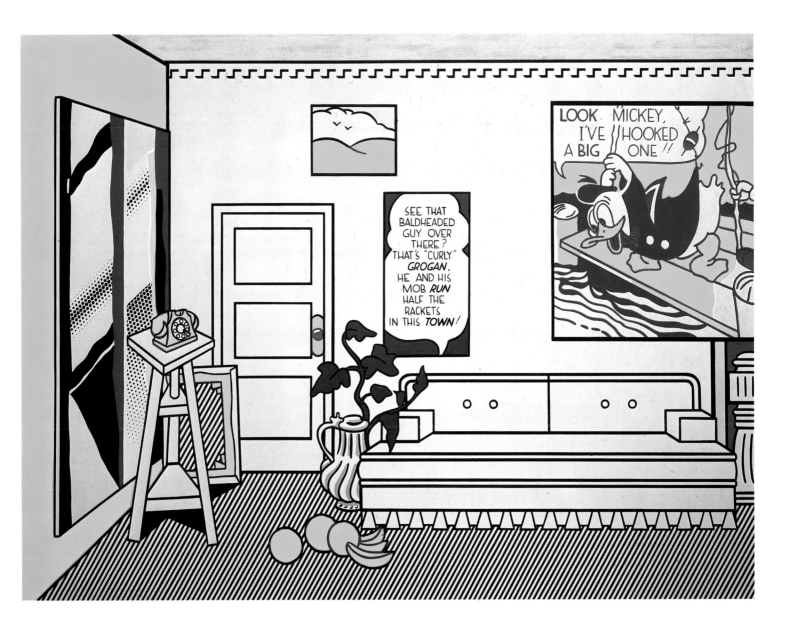

Within the image (part of the artwork, not transcribed as document text):
LOOK MICKEY, I'VE HOOKED A BIG ONE!!
SEE THAT BALDHEADED GUY OVER THERE? THAT'S "CURLY" GROGAN, HE AND HIS MOB RUN HALF THE RACKETS IN THIS TOWN!

Artist's Studio, Look Mickey, 1973
Oil and magna on canvas, 243.8 × 325.1 cm
Minneapolis (MN), Walker Art Center

surrounded industry at that time. For example, the logical,
economic functioning of machinery was understood as a metaphor
for things like honesty, clarity and collectivism. This rather poetic,
irrational seed existed in modernism from the very beginning, but it
bloomed out of all proportion during the period known as Art
Deco, a style Lichtenstein used as inspiration mainly between 1966
and 1970.

Art Deco was a decorative style, yet it did not fight against the
mass production of objects and images. It knew that the age of the
handmade object was over. Still, Art Deco wilfully misunderstood
the purist theory of functionalism: ornament exterior to the practi-
cal design of an object was not a sin, but a delight. Lichtenstein was
attracted to Art Deco because of its avid yet irrational hunger for
heroic industrial forms, seasoned by a Cubist aesthetic. As Lich-
tenstein saw it, Art Deco was the dessert following the nourishing
main course of modernist theory: "The obvious things, the simplic-
ity and the geometry and all that, influenced by Cézanne's state-
ment about the cube, cylinder, and the cone, all got made into art

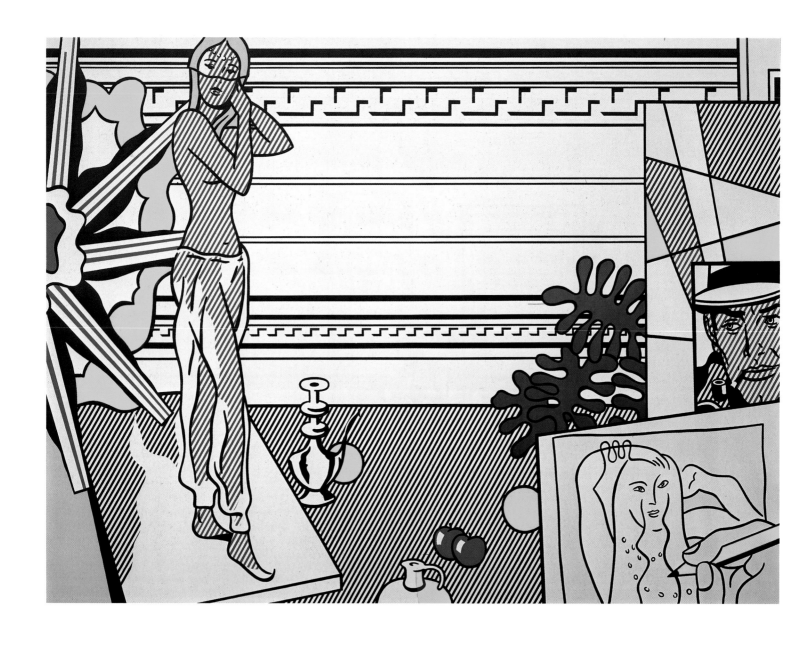

The Artist's Studio – with Model, 1974
Oil and magna on canvas, 243.8 × 325.1 cm
Private collection

objects – and nonsense. Sometimes it was beautiful nonsense." Art Deco architecture, especially details like doorways, window pediments or railings, but also furniture and jewellry, inspired Lichtenstein to both paintings and sculpture. Sometimes he actually went out and looked at buildings and their ornamentation, since New York is rich in architecture from this period (Ill. p. 80). Sometimes he looked in old magazines or books for ideas. French Art Deco struck him as particularly elegant. Lichtenstein had previously shown some interest in similar subject matter. Of course, the era of the thirties was the time of Lichtenstein's youth and there could be a certain amount of nostalgia present in his application of a thirties style. An early drawing of an airplane (1961) seems to show an old toy in flight. Its placement before a cloud is so central and stationary, however, that neither the spinning propellers nor the streamlines on its fuselage or on the cloud indicate movement. Lichtenstein probably used a thirties drawing for his model, where the streamlines were more decoratively than expressively meant. Another

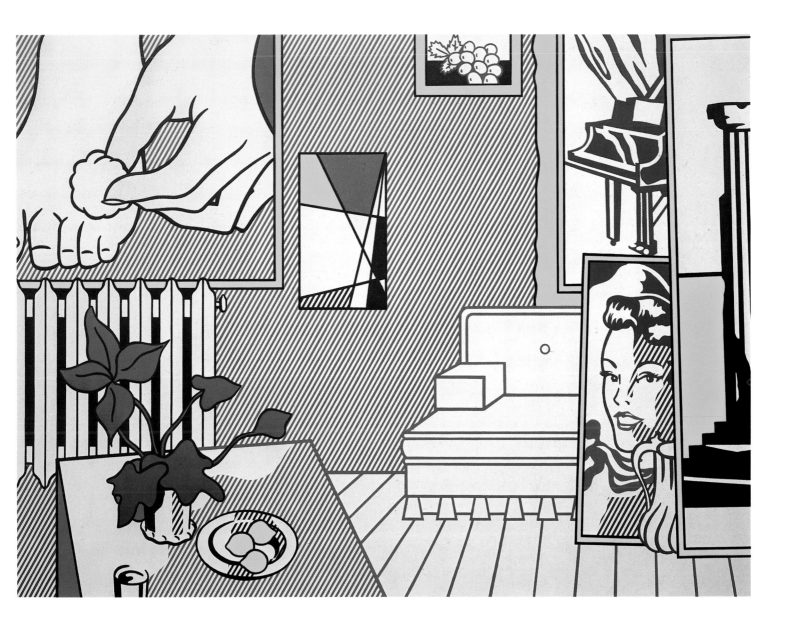

work, *Modern Painting with Floral Forms*, also from 1961, uses Fernand Léger's *Marguerite* from the mid-forties as its point of departure. It might just be Lichtenstein's first "modern" painting, even though he was to expand the modern theme more elaborately after 1966. The organic quality of Léger's forms has been transformed into an image that could well have functioned as an Art Deco architectural relief. While Léger allows some natural forms to appear, Lichtenstein has taken all of their naturalness and suggestiveness away.

Lichtenstein's *Modern*, Art Deco-inspired sculpture tends to look like an abbreviated version of its architectural and craft sources, stopping rather frustratingly short of functionality. Made for the most part of glass and metal, the sculpture seems to be making yet another ironic point concerning a style of art, namely, minimalism. Minimalism, like its contemporary Pop Art, rejected subjectivity and emotionalism. Often industrial in nature, it found its reduced forms within the tradition of geometric abstraction. Lich-

Artist's Studio, Foot Medication, 1974
Oil and magna on canvas, 243.8 × 325.1 cm
London, Collection James and Gilda Gourlay

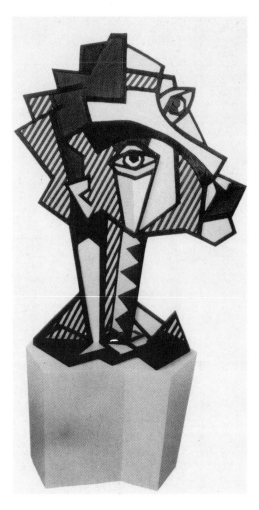

Expressionist Head, 1980
Painted bronze, 139.7 × 113.7 × 45.7 cm
Edition: six copies

tenstein's sculpture seems formally indebted to the smooth, slick surfaces of works by minimalist artist Donald Judd, who made box-like structures with a fine sense of volume and balance. Lichtenstein recognized modern design's implications for the minimal aesthetic. Using Art Deco, he created an antic minimalism.

The *Modern* paintings are much further away from their original sources than are the sculptures. They become experiments in surface decoration. The Benday dots, which had always exercised a secondary, decorative function, almost seem at home in them. In *Paris Review* (Ill. p. 40), Lichtenstein has put together various Art Deco motifs, arranging them on the canvas so that a broken, dynamic cross-shape determines the composition. A reference to the human form is to be found in the round yellow form with hanging "arms". The undulating lines relate to the streaming speed lines applied indiscriminately to nearly every object thinkable during the thirties. Maybe the title is meant to remind the viewer that Art Deco was most successful as *les arts décoratifs*, after it gained popularity at the Paris Exposition of 1925. Yet although the painting tries to suggest a magazine cover or exhibition poster through its format and logo, it is clearly a much brighter and harder version of this extremely sensuous style. Lichtenstein has stuck, of course, to his primary colors and outlining. What is most curious about this layering of industrial-feeling shapes is it flatness; despite the strata of forms, there is still absolutely no attempt at creating depth or space. It really is a surface review of a style, as if Art Deco were experiencing the bright highlights of a life flashing before its eyes. Tellingly, Lichtenstein never revitalizes the by-gone styles he uses.

At first, Lichtenstein's Art Deco images might seem somewhat removed after the comics paintings, since they do not contain the same kind of obvious, popular imagery. In order to understand the intended irony, it becomes necessary to follow Lichtenstein's own ideas about why he chose the subject matter. His view of Art Deco as a decorative corruption of modern principles made it analogous to the comics, since it pretended to deal with a serious subject (modernism), but could not be taken seriously. Lichtenstein identified with Art Deco as much as he did with the comics. When it became exaggerated and bombastic, as on Roosevelt Plaza, it involuntarily caricatured itself. Lichtenstein enjoyed this.

The *Modern* paintings include many that are "modular" as well. *Modular Painting With Four Panels* (Ill. p. 43) is a large square composed of four smaller square canvases – a building block technique reminiscent of minimalist Carl André's geometric sculptural units. The same motif appears on all four modules. The design is so cleverly conceived that both the concentric forms and the central diagonal lines perform unifying functions. The formal relationship of a painting like this to the hard-edge, shaped-canvas paintings of

Self-Portrait II, 1976
Oil and magna on canvas, 177.8 × 137.2 cm
New York, Paul and Diane Waldman

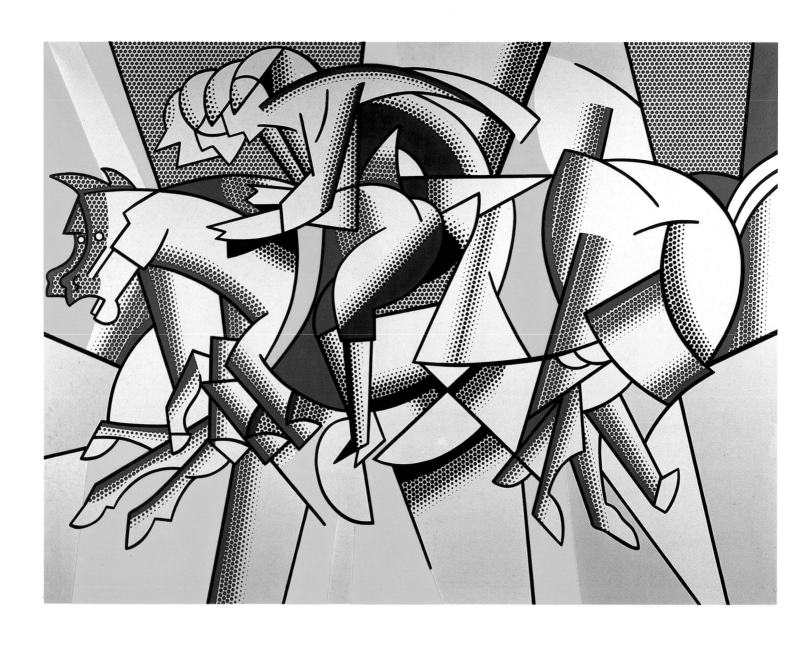

Red Horseman, 1974
Oil and magna on canvas, 213.4 × 284.5 cm
Vienna, Museum Moderner Kunst
Aachen, Sammlung Ludwig

an artist like minimalist Frank Stella is not hard to see. Both play with the linkage of geometric shapes and colors, both feature flatness and an absence of expression. Stella's famous statement, "What you see is what you see", meaning that his paintings were self-contained, self-sufficient entities, could also have applied to Lichtenstein's imagery, which often seems to defy any meaning beyond its very existence. A state of mind unites the two artists, who both are "realists" in the sense that they create art that obtrudes upon the viewer with its visual immediacy. As Lichtenstein said about his own work, "It doesn't look like a painting of something, it looks like the thing itself."

In a documentary film by Emile de Antonio, Stella once said that it was Jackson Pollock's cheating which gave him the idea for his shaped canvases. According to Stella, although Pollock claimed to work spontaneously without thinking about the painting ground, he did not really forget the edges of the canvas. Stella said that when he looked carefully at the corners of a Pollock, he often saw the drip marks changing direction and heading back towards the

Forest scene, 1980
Oil and magna on canvas, 243.8 × 325.1 cm
Private collection

other side of the painting. Stella felt he had caught Pollock in the act and it gave him the idea of making the canvases "fit" the painting. Might not this aspect of Stella's art also be understood to have its ironic side? The bands of color that compose Stella's paintings and ultimately define their perimeter are consistently and perfectly worked out.

Lichtenstein might well have been responding to Stella's perfectionism in his "Perfect" and "Imperfect" paintings series. At least, the coy humor he develops in this series deals with the absurdity of working out the surface of an abstract composition on a rectangular canvas. Square or rectangular formats have dominated painting ever since the medium freed itself from its mural duties, and artists who used eccentrically shaped canvases did so with a calculated effect in mind. Lichtenstein's "Imperfect Paintings" have more corners than those found in a rectangular canvas. The line separating the fields of color is to be understood as a line of continuous movement. It begins somewhere on the canvas and runs on, deflecting from the edges of the canvas much as a billiard ball ricochets off

69

the sides of a billiard table. Needless to say, in the imperfect paintings it overshoots its mark, while in the perfect paintings it remains quite obediently within the traditional four-cornered limits of painting.

Modern art could be rather primitively explained as a long list of "isms", which were usually given their names by ridiculing critics. Their unacceptable, avantgarde positions were tamed one after another; their names – Impressionism, Cubism, Fauvism, Futurism, Expressionism – have in the mean time become neutral historical terms. Over the years, Lichtenstein has responded to almost all of the modern movements as if he were strolling through a shopping market of styles. In his response to art history he did not obey chronological order, since the styles were essentially only closed formal units with which he chose to play.

Impressionism may well enjoy the greatest popularity of any "ism" today: there is a little something for everyone in it. It no longer looks avantgarde or outrageous, although it once was just that. Its subject matter, thought to have been vulgar at the end of the last century, now looks perfectly respectable, even pretty. Its dissolving forms and play with light, which once appeared to be merely unskilled painting, now make it as relaxed and harmonious as an August afternoon. This popularity alone suggests Impressionism's appropriateness as a subject for Lichtenstein. While his series of generic landscape paintings from the midsixties may have been inspired by the numerous landscapes of the *plein air* Impressionist painters, Lichtenstein was to refer specifically to certain Impressionist works. Encouraged by art historian and critic John Coplans, who was organizing an exhibition of serial images, Lichtenstein chose pictures that had appeared in serial production: Claude Monet's haystack and cathedral imagery. As Coplans must have realized, the industrial implications of the series concept suited Lichtenstein's aesthetic.

Rouen Cathedral (Seen at Three Different Times of Day) II (Ill. p. 71) (1969) shows different views of the cathedral façade which may or may not look as it is when bathed in the light of different times of day. Although Lichtenstein retained Monet's intention in the title, he did not try to fulfil it himself: "My series is supposed to be times of day only because that is the way his were, and because it's kind of silly and fortuitous and obviously not about daylight at all." Lichtenstein has omitted outlining the forms in black; apparently it was important not to distance Monet's images too far from their original style. Only the usable characteristics of Monet's painting were adopted, no new ones were added. Pure, overlapping layers of Benday dots mechanically recreate the blur of Impressionist brushstrokes. Just as in an Impressionist painting, the Benday dots mix and change during their viewing. Lichtenstein

Carlo Carrà
Red horseman, 1913
Il cavaliere rosso
Tempera and ink on paper, 26 × 36 cm
Milan, Pinacoteca di Brera, Collection
Jucker

must have enjoyed the Op Art effect that sets in when the viewer tries to separate the layers of Benday dots from one another, since it added yet another level of contemporary meaning to the work.

In 1974 Lichtenstein painted his *Red Horseman* (Ill. p. 68) after the Futurist work of the same name (Ill. p. 70). The Futurist Carlo Carrá was intent on communicating pathos, speed and heroicism, the smell of human and animal sweat and the rumble of galloping hooves. Although he divides the surface of both horse and the rider into structural units, Carrá shades these units as if to imply depth and volume. The horse's head seems mechanical; the rider's bare foot is drawing a circular shape that suggests the pedal of a bicycle – in 1913, when the "Red Horseman" was painted, the bicycle was still a relatively sophisticated mechanical device. The vibrating outlines of Carra's shapes communicate movement in time. His chromatic choice – shades of red, yellow and blue – have been retained by Lichtenstein, who, however, once again applies them as unmixed, pure primary colors, breaking them down into Benday dots to achieve half-tones. The emotional values of the original disappear. Lichtenstein refers almost playfully to volume by gradating the size of the Benday dots, yet the feeling of flatness does not really disappear. Perhaps the greatest change has occurred in the way the individual parts of the composition have been stripped of their relative importance. While Carrá emphasizes the rider, as well as the haunches, feet and shoulders of the horse, Lichtenstein integrates the entire image democratically into the background. All of Carrá's steamy action is gone. What is left is the carapace of the image from which the souls of rider and horse have fled.

Rouen Cathedral (Seen at Three Different Times of Day) Set No. 2, 1969
Magna on canvas, 160 × 106.8 cm
Cologne, Museum Ludwig

In 1963, Lichtenstein criticized art about art in an interview with Gene Swenson: "I think art since Cézanne has become extremely romantic and unrealistic, feeding on art; it is utopian. It has had less and less to do with the world, it looks inward, neo-Zen and all that. This is not so much a criticism as an obvious observation. Outside is the world; it's there. Pop Art looks out into the world; it appears to accept its environment, which is not good or bad, but different – another state of mind."

It seems contradictory for Lichtenstein to define Pop Art as something that looks out into the world, when he himself only works with two-dimensional subject matter. This is the point at which Lichtenstein betrays how traditional he actually remains. As a painter, he seems doomed to working within an art context, since it is his world. Sometimes he looks at art in order to discover its Achilles heel, or maybe its funnybone. Sometimes he seems more interested in problems of form. Yet he always manages to rob high art of our respect by putting it into a low art context. Lichtenstein's view of the world is clearly expressed in his paintings of paintings. His real work was that of a saboteur, toppling the esoteric thing that art had become.

Landscape with Figures and Rainbow, 1980
Oil and magna on canvas, 213 × 305 cm
Cologne, Museum Ludwig

In a 1964 radio interview with Claes Oldenburg, Lichtenstein and Andy Warhol, Warhol stated flatly that the "wrong people" were interested in art: "But the people who don't know about art would like it (Pop) better because it is what they know." Lichtenstein shares a similarly anti-elitist stance, although he works with the knowledge that only an art-interested public would have. All of the Pop artists yearned for the authenticity that everyday objects and subject matter were supposed to give their work. Still, it was difficult for them actually to transcend the art world itself. As Oldenburg said in the same radio interview about the Happenings and Pop-shows he put on, "When you come to a town they think you are going to be something like the Ringling Brothers . . . and you find people becoming disillusioned because it turns out to be just the same old thing – Art." Maybe Lichtenstein was the cleverest of these artists, since he didn't try to find his way out of this vicious circle. Instead, he turned art about art into a tool.

Pow Wow, 1979
Oil and magna on canvas, 247 × 305 cm
Aachen, Neue Galerie – Sammlung Ludwig

73

Sidestepping Abstraction

Lichtenstein tends to work in thematic groupings and critics often divide his art according to its subject matter. Yet it is somewhat misleading to separate Lichtenstein's oeuvre into such groups, since many of the same interests and concerns keep cropping up in whatever the artist chooses to work upon. During the seventies, several new subjects were developed in series, in addition to the ongoing appropriation of works of art. If one has understood the mentality behind Lichtenstein's work up until this point, it is possible to continue speculating about the artist's humor and irony, as well as testing the flexibility of one's own responses to art and art history.

However, there are two series of paintings and drawings done in the seventies which seem more purely serious, less ironic in their subject matter and treatment than other works of Lichtenstein. The *Mirrors* and the *Entablatures* are drier and cooler in feeling and seem even more concerned with the surface design of the canvas than did the Art Deco-inspired work which preceded them. Was Lichtenstein becoming more interested in minimal or abstract art? The *Mirrors* and the *Entablatures* (both of whose titles are always suffixed by a numeral) appear to be opportunities to steer his painting in such directions without totally getting rid of a figurative subject.

The level of abstraction is so extreme in the mirror series that if the title did not reveal to the viewer what is meant by the image he or she would probably not recognize that a particular object was being shown. Similar to Lichtenstein's early works, the *Ten Dollar Bill* (Ill. p. 9) or *Compositions* (Ill. p. 62), the canvas and the image correspond to one another, so that the painting appears to be the thing itself. Like many real mirrors, these works may be round, elliptical or rectangular; the rectangular *Mirrors* are composed of separate vertical panels. Unlike the *Modern* paintings, no overall repetitive design unites the compositions made of more than one canvas. All in all, few colors are used, although they may be domin-

Mirror No. 1, 1969
Oil and magna on canvas, 152.4 × 121.9 cm
Private collection

Plus and Minus (Yellow), 1988
Oil and magna on canvas, 101.6 × 81.3 cm
Private collection

Double Mirror, 1970
Oil and magna on canvas, 167.6 × 91.4 cm
Collection Werner-Erhard Charitable
Settlement

Mirror in six Panels No. 1, 1970
Oil and magna on canvas, 243.8 × 274.3 cm
Vienna, Museum Moderner Kunst,
Aachen, Collection Ludwig

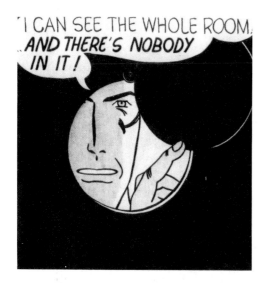

I can see the Whole Room and There's Nobody in It, 1961
Oil on canvas, 122 × 122 cm
Meriden (CT), Collection Mr. and Mrs. Burton Tremaine

Self-Portrait, 1978
Oil and magna on canvas, 177.8 × 137.2 cm
Private collection

ant ones and take up large areas of the canvas. Reflections and shadows are signalled by Benday dots applied in sections of varying directions, gradations and densities.

In *Mirror 1* from 1971, not even half of the light background has been covered with Benday dots, while a solid strip of yellow denotes a reflection off the bevelled edge of the mirror. *Mirror 2* uses diagonal castings of Benday dots and a wide vertical swathe of black. Ought the viewer to understand the black as a reference to reflected depth, perhaps the opening of a door onto another room? This would be an acceptable way for Lichtenstein to present depth in the guise of flatness. Indeed, the similarity in flatness between a reflected image and a printed image – be it a photograph or a drawing – may have drawn Lichtenstein to the subject in the first place. The reversal that occurs when something is reflected in a mirror, as well as the cold, silvery effect of the looking glass estrange the real object or face from its actual self. This, too, offers a parallel to Lichtenstein's style, which strove to be as emotionless and machine-like as possible and which carefully distanced itself from first hand experience. Even the material of the mirror is related to a part of Lichtenstein's art – his glass and metal sculpture from the Art Deco period. Although it at first does not seem likely that the same logic governing his choice of Picasso, Mondrian, or Monet could be at play here, once again Lichtenstein takes up a kind of image because it seems to be formally in synch with his own style.

Mirror 6 (Ill. p. 79) is a round canvas that is completely blue except for its bevelled rim, which is indicated by black Benday dots and a line that begins thin and becomes thicker, only to break off into a thinner line once again. As can be seen here, the *Mirrors* sometimes seem an excuse for a short excursion into monochrome abstraction. The blueness of this image irritates the viewer with its blank non-vision; the room in which he or she is standing must be darkened and empty. Clearly, though, this is not the case, or else the painting itself would not be visible. In 1961 Lichtenstein had taken over an image from a comic book in which the viewer sees only part of a man's face visible behind a black wall (the picture plane). He is peering through a small, round aperture whose shutter he has pushed aside and is holding in place with a single finger. The viewer understands him or herself to be on the other side of the wall in a dark room similar to that reflected in the blue mirror; however, the man in the comic frame doubts any such existence: "I Can See the Whole Room and There's Nobody in It".

The resemblance between the blue *Mirror 6* and the early comic painting is more than fortuitous. Through the use of both an empty mirror and an empty room, Lichtenstein is negating the subjective experience of a viewer of his art. None of the nearly forty mirror paintings reflects a living presence; instead, the Benday play of light

Mirror No. 6, 1971
Oil and magna on canvas, ⌀ 91.4 cm
Private collection

Entablature, 1974
Oil and magna on canvas, 152.4 × 254 cm
Private collection

and shadow suggests the careful angling of the mirrors so that they remain empty. Curiously enough, in a painting entitled *Self-portrait* (Ill. p. 78) (1978), Lichtenstein uses an empty mirror in place of a head, while a white T-shirt represents his upper body and shoulders. Is this a do-it-yourself portrait, like the *Time* Man-of-the-Year title page mirrors, where any face fits? In *Portrait* (1977), a blank mirror is crowned by a blonde wig in a sort of ancient vanitas symbolism, while including other Lichtenstein painting elements into the composition. (It is interesting to compare Andy Warhol's portraits of the seventies to these works, since they, too, are "empty" faces abstracted from flat Polaroid snapshots of his sitters.)

In addition to this first level of understanding, the blue mirror also shows the way a weighty art theme dealing with abstraction – the monochrome surface – can have its standpoint jostled by simply having the rug pulled out from under its feet. When Russian Suprematist Kasimir Malevich placed his black square on a white background in 1913, he wanted to make a new, pure painting untainted by recognizable objects. Lichtenstein is doing this, too, in a way, yet through their very absence, the missing objects and figures become conspicuous omissions.

The mirrors offer Lichtenstein the opportunity of making a thing as immaterial as light into a defined presence, much as he had

done with the flash and flames of the explosions. The reflected light also shares something of the brushstroke paintings' hardened rippling. As Jack Cowart of the St. Louis Art Museum rightly noticed in his catalogue about Lichtenstein's work of the seventies, both the *Entablatures* (Ill. p. 80) and the *Mirrors* have this play of light in common. In the *Entablatures,* many of the forms are drawn purely by the shadows that they cast.

There are two forms of *Entablatures:* black and white or color versions (Ill. p. 80) partly executed in metallic and textured paint. The format of the works is horizontal, once again making the canvas and the actual thing shown congruent. Where did the idea for the classic *Entablatures* come from? The *Temple of Apollo* (Ill. p. 81) (1964) was an early painting of one of several isolated architectural monuments that Lichtenstein portrayed, including a common barn and the Great Pyramid. The entablature of the Apollo temple is, however, not closely related to the architectural details of the *Entablatures,* if, indeed, it is related at all. While the temple painting as a whole shows the symbol of a cliché tourist attraction, the *Entablatures* do not have the same kind of signal function.

Apollo Temple IV, 1964
Oil and magna on canvas, 238.8 × 325.1 cm
St. Louis, Collection Mr. and Mrs. Joseph
Pulitzer Jr.

Although immediately recognizable as classic detailing, they are entirely anonymous and formally much more concerned with an overall surface decoration of the canvas. Here, too, as in the mirror paintings, the play with depth occurs only on a conceptual level.

Lichtenstein took many of the patterns for his *Entablatures* from real buildings in New York. Yet if one had to find a kindred spirit instead of a direct source for his work, one might take the hundreds of thousands of drawings of architectural details made by Beaux Arts architecture students during the nineteenth century as part of their training. The classic entablature and its various bastard offspring were one of the decorative variables of architecture which they had to master. It worked with a set vocabulary to create an abstract design which always "articulated" (as architectural historians put it) the same parts of a building. The most obvious aspect of entablature design – and certainly one that appealed to Lichtenstein's sensibility – is its mechanical repetition of elements which are totally devoid of emotion. Because of this, Lichtenstein's paintings seem segments of a much longer whole, at once both designs and things using some immutable sign language.

Paintings: Still Life and Stretcher Frame
1983
Oil and magna on canvas, 162.6 × 228.6 cm
Private collection

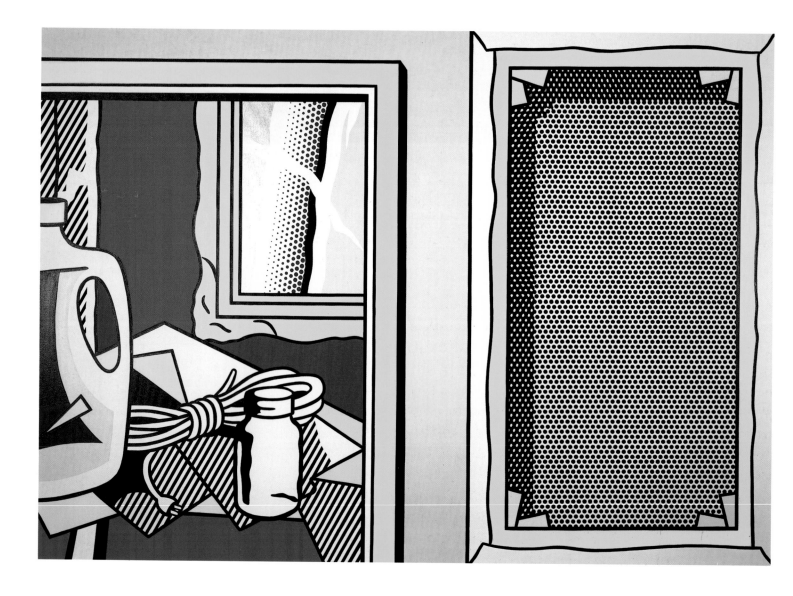

The *Entablatures* and the *Mirrors* contain some of the largest unmodulated surfaces of color in Lichtenstein's oeuvre. His affinity here to artists who worked within the tradition of geometric abstraction obviously does not mean that he shares their aesthetic completely. Lichtenstein remains within the figurative mode as if it were his natural element, even though he swims in as close as he can to the dry shore of minimalist abstraction. Instead of using the *Mirrors* and *Entablatures* as ironic commentary, Lichtenstein embraces in them a more esoteric, even hermetic minimalist quality. The public behaved accordingly: both series were hard to sell at first. Could Lichtenstein have been reacting to the way Pop Art had been appropriated by the moneyed class and artists made into the pets of the jet set? Are the *Mirrors* and *Entablatures* a withdrawal from an overenthusiastic market that wanted to be entertained by popular imagery? Pop Art had been intended originally as an affront, yet already in 1963 Lichtenstein commented about the use of commercial subject matter that "apparently they didn't hate that enough either." Perhaps such drier, less spectacular subjects allowed Lichtenstein to work on his concerns in a form less likely to be easily and superficially consumed.

Paintings: Tomatoes & Abstraction, 1982
Oil and magna on canvas, 101.6 × 152.4 cm
Private collection

83

Compilations, Syncopations, Discombobulations

During the same years that Lichtenstein was working on the *Mirrors* and *Entablatures*, he continued to make paintings that were cartoon-like in nature. It was as if different series of his work satisfied different sides of his personality. *Cow Triptych (Cow Going Abstract)* (1974), actually inspired by a painting by Theo van Doesburg and a lithograph series of Picasso, makes a joke out of how to turn a recognizable cow into an abstract one. Lichtenstein slyly reverses the process of *How to Draw* books, in which geometric forms are suggested as the building blocks for what eventually developes into a convincing-looking thing. Because it is a triptych with a "story line", the viewer has a chance to compare the relative merits of realism versus abstraction. One finally realizes that the one can be as banal as the other, although the abstract image disguises its cud-chewing starting point. *Cow Triptych* enjoys dissassembling the cow in a playful gesture. As it turned out, Lichtenstein was about to embark on a relaxed and humorous spree of rearranging imagery.

In the seventies and the eighties Lichtenstein began to loosen, reorganize and expand what he had done up until that point. His quotations of art sometimes combined elements of only his own works, while in other paintings he started to mix various artists' images and styles together, changing them according to his own fantasy. The early art-oriented paintings had often concentrated on re-working a single image. Yet as he went on, Lichtenstein became more and more uninhibited about piecing together diverse borrowings. He also began to work on the traditional theme of the still life, thus expanding the idea of his early single object images without actually quoting them.

A series of *Artists' Studios* touches upon individual works and generic groups of Lichtenstein's paintings which had been executed since 1961. The name *Studios* is fairly misleading, since no paint brushes or easels appear in the closed rooms shown. Lichtenstein's

Stretcher Frame, 1968
Oil and magna on canvas, 91.4 × 91.4 cm
Private collection

Portrait II, 1981
Magna on canvas, 101.6 × 152.4 cm
Private collection

Studios are more like museums than workshops. They were an opportunity for the artist to review his whole work and, at the same time, to play with the ambiguous "reality" of his images. From the very beginning, Lichtenstein's paintings had an extremely strong presence that had made them seem like things instead of pictures of things. Now, in the *Studios,* these objects came to life as furnishings for stiff-looking living rooms. For example, in *Artist's Studio, Look Mickey* (Ill. p. 63) (1973) the couch, the door, the wall frieze, the telephone and the fruit on the floor have freed themselves from various works of Lichtenstein and assembled in an interior decorator's context. Other paintings are actually shown as paintings. *Look Mickey,* (Ill. p. 11) Lichtenstein's first comic painting, is the most well-known of the artist's works in this *Studio.* The mirror and the *trompe l'oeil* painting posing as the rear side of a canvas are

Red Barn through the Trees, 1984
Oil and magna on canvas, 106.7 × 127 cm
Private collection

Sunrise, 1984
Oil and magna on canvas, 91.4 × 127 cm
Private collection

also recognizable as existing Lichtenstein works. Two other paint-
ings were experiments in form: the gull and dune landscape over the
door became an actual painting only a year later, while the text
balloon image about the baldheaded guy never escaped the *Look
Mickey Studio*. There are also references to the art of Matisse and
Braque. The telephone table, the lidded jug and the plant come from
Matisse. The baluster to the right is a fragment borrowed from
Braque. However, in the *Studio* series, such borrowings are less a
reference to other artists than they are tokens of Lichtenstein's
borrowing technique itself. For someone familiar with the artist's
oeuvre, the *Studios* could become mental playgrounds. The lucky
collector who bought *Artist's Studio, Look Mickey* got at least ten
Lichtensteins for his or her money, provided he or she is capable of
finding them.

What becomes most clear in the *Studios* is that the overall
surface decoration of the canvas had slowly become more and more
important for the artist. While earlier compositions leaned heavily
on those of their sources, during the seventies and eighties Lichten-

Two Apples, 1981
Magna on canvas, 61 × 61 cm
Private collection

Landscape with Red Roof, 1985
Magna on canvas, 274.3 × 195.6 cm
Private collection

stein became formally much more independent. His compositions were now entirely his own, even if their components were borrowed. In the *Studios,* the room situation remains understandable, although sometimes the layering of canvases propped up against each other on the floor instead of hanging on the wall, such as in *Artist's Studio with Model,* (Ill. p. 64) easily confuse a logical sense of space. This layering of images later develops into a freer, intuitively organized pastiche style with few references to real places.

Another series, the *Trompe l'Oeil* (Ill. p. 50) paintings, combine many aspects of Lichtenstein's work. Traditionally, *trompe l'oeil* painting is a special kind of still life that tries not to look like a painting at all. Usually things like small tools, photographs, framed images, a playing card, envelopes or an insect are shown in an extremely realistic fashion against a flat wall. The *trompe l'oeil* artist must be a virtuoso painter, since he tries to fool the viewer into believing his alternative reality completely. Like Lichtenstein, the traditional *trompe l'oeil* painter liked to work with two-dimensional objects, since the depiction of a real flat object was a ticklish problem. Pictures within pictures toss up questions about reality as no other subject can. During the nineteenth century, American artists in particular liked to work in this genre. For the first time, Lichtenstein uses American artists as sources when he cites works by such painters as John F. Peto or William M. Harnett. In *Things on the Wall* (1973), Lichtenstein can show such disparate things as a Léger figure, paint brushes, horse shoes (a reference to Harnett's *Golden Horseshoe* (1886), and a wood grain pattern all together. Because of their traditionally composite nature, the *Trompe l'Oeil* works would lead Lichtenstein naturally to his later riotous combinations of styles and images.

As in the *Studios* series, the still life paintings of the mid-seventies (Ill. p. 53–57) have rooms as their settings. Their compositions have also been invented entirely by the artist, who seems even to have made the arrangements of objects himself. They are the first works by Lichtenstein that were drawn from life instead of from mail order catalogues or advertisements. Appropriately, the "life" here, however, is inanimate. Although the paintings show domestic and office items placed on tables, desktops or chairs, no real sense of space is created. Rather, Lichtenstein is interested in showing the inherently abstract forms of everyday objects. The Benday patterning in the *Still Life* series is often that of the stripe, which harmonizes with the many geometric and linear forms sought. For example, *Still Life With Folded Sheets* (1976) used the sheets and the closet slats to set up formal analogies to the Benday patterning.

In the Surrealist series from the end of the seventies, Lichtenstein abandoned the idea of an interior room and moved on to a pastiche style. Art critics had sometimes called Lichtenstein's work

Surrealist, for want of a better term, and according to the art historian Jack Cowart, in the Surrealist series, Lichtenstein began to compound this misunderstanding on purpose. Surrealism was one of the only modern art movements that Lichtenstein had not yet quoted and for the first time he applied another style's precepts to his own subject matter. (For example, the red lips of the teen comics heroines appear as independent organs isolated against the background or standing up on end. The Surrealists had often used single human organs such as eyes or lips for their disturbing, often erotic, connotations.) Surrealism, officially created by André Breton in 1924, wanted art to be fed by the human subconscious. Dreams were an especially important source for these artists, whose main goal was authenticity of expression, free of academic rules and rational decisions. Lichtenstein gave himself over to a similarly intuitive and imaginative attitude and became much less rigid in his planning. The strange combinations of figures and puzzling shapes share something of Surrealism's original aggressive illogicality; however, they are not at all disturbing on a subconscious level. Vestiges of his old work turn up in new shapes, connected only by playful relationships of form and rhythm. The painting itself remains crisp and definitive, although it has a new happy, extroverted quality.

In a painting like *Pow Wow* (Ill. p. 73) (1979), some of the Surrealist forms return, combined with American Indian motifs. The tipped eye and lips are coupled with teepees and pictographic Indian symbols, all of which are bathed in a sea of Benday patterning. This is a less unlikely combination than it at first seems. Since Indian designs were often based on visions or dreams, they share a common source with Surrealism. One Surrealist artist, Max Ernst, had even been influenced by his exposure to the Hopi Indian culture in Arizona. As far as Lichtenstein's aesthetic is concerned, the clear, flat decorative surfaces of Indian arts and crafts must have seemed formally related to it. Besides, his early Cubist-inspired paintings from the fifties had dealt with Western themes, including some Indian subjects. Indians are, after all, the only authentic Americans and their art provides a foundation for the American culture that displaced them. Cowart relates additional reasons for Lichtenstein's attraction to Indian forms: artist friends of his such as Jasper Johns, Frank Stella and Donald Judd collected Indian blankets for their designs, while Lichtenstein himself lives near a Shinnecock Indian reservation on Long Island. For Lichtenstein, Indian art was analogous to African art, which lay at the root of European Cubism. By using Indian images, he corroborated the stimulating effect of ancient and primitive art forms upon industrial cultures.

As in the *Studios*, the gigantic *Mural With Blue Brushstroke* (Ill. p. 91) that Lichtenstein executed in 1986 for the Equitable

Roy Lichtenstein in front of his
Mural with Blue Brushstroke, 1986
22.3 × 10.8 m
New York, Equitable Tower

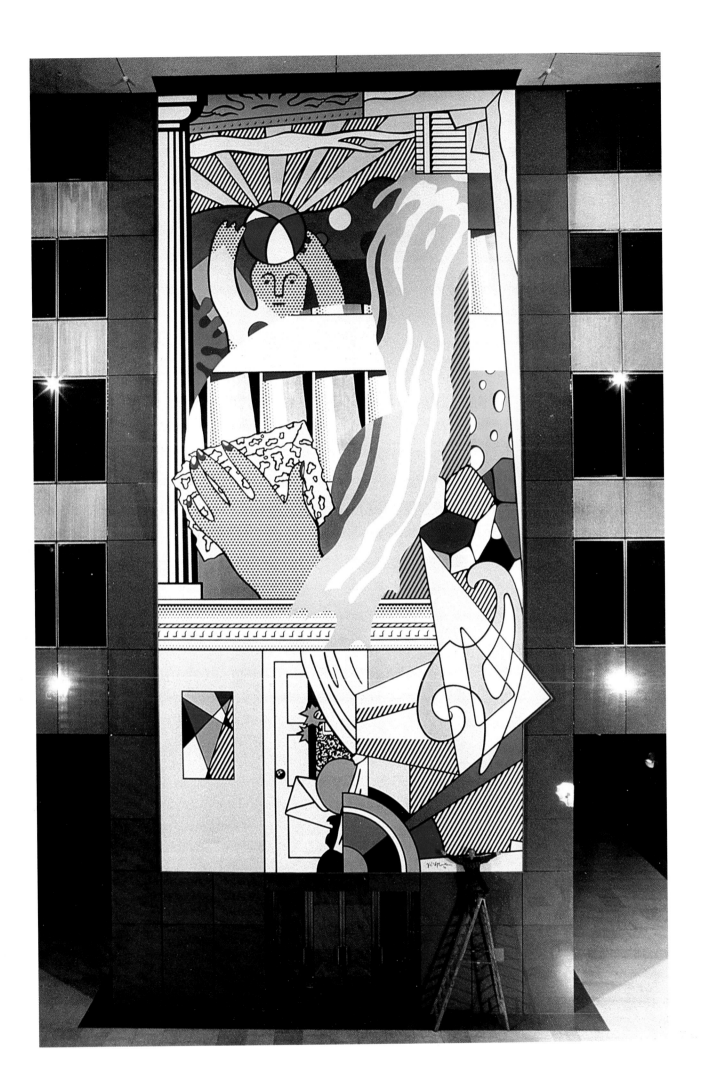

Imperfect Painting, 1986
Oil and magna on canvas, 284.5 × 426.7 cm
Private collection

Tower in New York quotes or re-phrases many of his own works, as well as those of other artists. The door, part of a mirror and an entablature had already been used in *Artist's Studio, Look Mickey*. But the mural carries Lichtenstein's work a step closer to abstraction by assembling the images as if they were building blocks that move back and forth between meaning and form. The beach ball from 1961 is no longer in the hands of a beautiful young woman; instead, a Léger figure tosses it up into the air. The ball's upper crescent has become the rising sun of a landscape, whose rolling hills are scarred by random Benday dots. A section of Swiss cheese seems to echo their form in a negative way, while also referring to the sensual shapes of the sculptors Jean Arp and Henry Moore. Works by Jasper Johns, Frank Stella, Matisse, but also Art Deco and a classic temple put in what threatens to be a quick appearance, since a ladylike hand is busy sponging the whole mural away. *Mural with Blue Brushstroke* may be a huge public work, but Lichtenstein is apparently skeptical about the immortality of art. A streaming blue waterfall in the guise of Lichtenstein's brushstroke – minus its texture – pours down from one corner as if to help with the cleansing. This attitude is very revealing. Lichtenstein was given the opportunity of using this public space to reach hundreds of New

Yorkers every day, but he chose not to try to teach them anything. Instead he offers them a hedonistic view of earthly insignificance.

Although all of these images are bound together formally, they make up a pastiche. It is not surprising that Lichtenstein arrived at the final composition by using a collage model. After the final arrangement of images was decided, slides of the collage were made and projected onto the wall of the building. Lichtenstein, together with assistants, drew the outlines of the mural after these slides. Later the outlines were filled in with the artist's choice of colors, which had been extended over the past few years to include solid intermediary shades like orange and grey. As the artist explained to Calvin Tomkins in a book about the mural, "I like the concept of using five colors, like in cartoons. I'm going to use eighteen or so in the mural. I've gotten weak in my old age and have decided to have certain subtleties, even though I hate the idea." By succumbing to the temptations of color, Lichtenstein had finally done away with the reasoning behind the Benday dots. His original desire to be a painter surpressed his reservations about art as an institution.

Lichtenstein's explorations have not led him out of the maze of modernity, but during his excursions he has discovered (and rediscovered) a lot of territory. Maybe what is most important about Lichtenstein's oeuvre is its irritating contradictions and understated humor. By expropriating our visual imagery, he leaves us wondering what art in the twentieth century can still be.

The publishers would like to thank the museums, galleries, collectors, archives and photographers for their kind permission to print the pictures contained in this book. These include in particular: the Leo Castelli Gallery, New York, which allowed us to print a large number of illustrations, the Neue Galerie – Sammlung Ludwig, Aachen, and the Museum Ludwig, Cologne, as well as the photographers Bob Adelman, Rudolph Burckhardt, Ann Münchow, Eric Pollitzer, Grace Sutton, Kenneth E. Tyler and Dorothy Zeidman.
We would like to extend our deepest thanks to Roy Lichtenstein and his colleague Patricia Koch who have kindly helped and advised the publishers throughout production of this book. We are also grateful to Shelley Lee for her personal involvement in obtaining the illustrations.

Roy Lichtenstein: A Chronology

1923–1938 Born in New York City into a middle class home; father works as realtor, one sister. Happy, uneventful home life and childhood. Attends a private secondary school in New York, where art is not included in the curriculum. Begins as a teenager to paint and draw on his own at home. Becomes interested in jazz and attends concerts in the Apollo Theater, Harlem and at various jazz clubs on 52nd Street, which lads him to paint portraits of jazz musicians, often playing their instruments. Looks to Picasso for inspiration.

1939 Attends summer art classes at the Art Students League under Reginald Marsh, drawing directly from models or from the scenes and sights of New York: Coney Island, carnivals, boxing matches.

1940–42 Graduates from high school with the idea of seriously studying to become an artist. Because of the regional emphasis at the Art Students League, feels no need to remain in New York and enrols in the School of Fine Arts, Ohio State Uni-

versity. (One of few institutions that provides studio courses and a degree in fine arts.)

At Ohio State strongly influenced by Professor Hoyt L. Sherman: "Organized perception is what art is all about. He taught me how to go about learning how to look."

Freely Expressionist works from the model and still life.

1943–45 Drafted into the Army. Service in England, France, Belgium, Germany. Drawings from nature in wash, pencil, crayon. After the war is over, transfers from Germany to Paris. Studies briefly French language and civilization at Cité Universitaire.

1946–48 Returns to Ohio State University to continue art studies under G. I. Bill and graduates June 1946. Enters graduate programme and is hired as instructor.

Paintings mainly geometric abstractions followed by Cubist-inspired semi-abstract paintings.

1949–50 Graduates 1949 M. F. A. Ohio State University, where he remains an instructor until 1951. 1949 marries Isabel Wilson (divorced 1965). Exhibits in various group shows at Chinese Gallery, New York. First one-man show at Ten-Thirty Gallery, Cleveland, Ohio. First one-man show in New York at Carlebach Gallery.

Broad references to Americana in his work; references to Frederic Remington and Charles W. Peale within a Cubist style. Work gradually becomes looser, more Expressionist.

1951 Makes assemblages of found and carved wooden objects showing horses, knights in armor, Indians. Similar subject matter in the paintings, which fluctuate between Expressionism and Cubism.

1951–57 Moves to Cleveland, where he works as graphic and engineering draftsman, window decorator, sheet metal designer. Three one-man shows at John Heller Gallery, New York. Birth of two sons, David Hoyt Lichtenstein and Mitchell Wilson Lichtenstein. Appointed assist-

Roy Lichtenstein, age 9 months, 1924

Roy Lichtenstein, age 11, Summer 1934, Maine

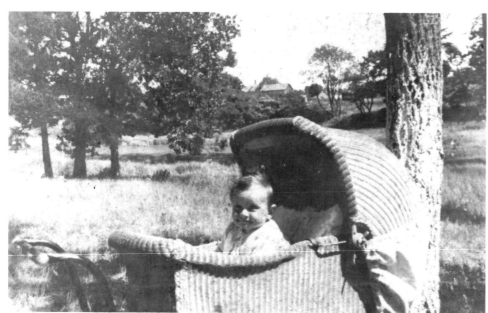

Roy Lichtenstein in front of "Mirror 1" ca. 1977
Photo: Renata Tonsold

Roy Lichtenstein, Dick Pollich
and Dorothy Lichtenstein at Tallix,

watching the patina being applied
to "Cup and Saucer 2" August 1977

ant professor of art, New York State University, Oswego.

1952–55 Concentrates on paintings with American subject matter. Exploratory use of Expressionism, abstraction, painted wood constructions.

1956 Makes humorous lithograph of a ten-dollar bill in a rectilinear shape, so that the image is a kind of counterfeit bill itself: proto-Pop.

1957–60 Paints in a nonfigurative Abstract Expressionist style. Occasional drawings of comic imagery (Mickey Mouse, Donald Duck, other Disney figures).

1958 One-man show at Condon Riley Gallery, New York. Abstract Expressionist paintings.

1960 Appointed assistant professor, Douglass College, Rutgers University, New Jersey. Moved to Highland Park, New Jersey. Meets Allan Kaprow, who also teaches at Rutgers, and is exposed through him to happenings, environments. Attends several happenings as a spectator and meets Robert Watts, Claes Oldenburg, Jim Dine, Robert Whitman, Lucas Samaras and George Segal. The happening/environment artists rekindle his interest in Proto-pop imagery.

1961 Begins first Pop paintings: cartoon images and technique derived from the appearance of commercial printing. Slightly altered comic-strip frames drawn with pencil directly onto the primed canvas and painted in oil.

Begins to use advertising imagery suggesting consumerism and homemaking.

In the autumn he leaves several of the new paintings with the Leo Castelli Gallery, New York. Several weeks later he sees work of Andy Warhol also using comic imagery at Castelli's. (Castelli takes Lichtenstein on as an artist, rejects Warhol.)

1962 One-man show at Leo Castelli Gallery. Included in "The New Paintings

Roy Lichtenstein, age 22, „European Theatre", 1945

Roy Lichtenstein, late 1940's

Roy and Dorothy Lichtenstein in their kitchen in Southampton, Summer, ca. 1977

Roy Lichtenstein in his studio, 1985
Photos: Grace Sutton

Roy Lichtenstein in his studio, 1985

Roy Lichtenstein in his studio, 1988

of Common Objects" at Pasadena Art Museum, first museum exhibition to centre upon Pop, and the "New Realists" show in the Sidney Janis Gallery, New York.

1962–64 Works deriving from Picasso and Mondrian.

1963 Participates in "Six Painters and the Object" at the Solomon R. Guggenheim Museum, New York. One-man shows at Leo Castelli Gallery; Ileana Sonnabend Gallery, Paris; Ferus Gallery, Los Angeles; Il Punto Gallery, Turin.

Granted year of absence from Rutgers University. Moves from New Jersey to New York.

1964–1968 Resigns from Rutgers University to devote himself full time to painting. Numerous one-man shows, including a retrospective exhibition (1961–1967) at Pasadena Art Museum. Retrospective show travels to Minneapolis, Amsterdam, London, Berne and Hanover.
Marries Dorothy Herzka.

1964–65 Paintings and ceramic sculpture of girls' heads derived from teen comics. Landscapes.

1964–69 Paintings of monumental or cliché architecture.

1965–66 Brushstroke series. Explosions.

1966–70 Modern paintings using imagery from the Thirties.

1969 Spends two weeks at Universal Film Studios in Los Angeles as artist-in-residence to make seascape film for the "Art and Technology" exhibition at Los Angeles County Museum of Art. Works in New York with Joel Freedman of Cinnamon Productions, experimenting with films.

Retrospective exhibition of work (1961–1969) at the Solomon R. Guggenheim Museum, which travels to Kansas City, Seattle, Columbus, and Chicago.

Exhibits in "New York Painting and Sculpture: 1945–1970" at the Metropolitan Museum of Art, New York.

1970 Moves to Southampton, Long Island. Paints four large murals of brushstrokes for College of Medicine, Düsseldorf University. Elected to the American Academy of Arts and Sciences. Two of his seascape films shown at Expo' 70, Osaka, Japan.

1970–1980 Numerous one-man gallery shows. Work reflects on illusion (*Mirrors, Entablatures, Tromp l'Oeil*) and other

works of art (Surrealism, Futurism, Expressionism, *Artist's Studios*). 1979 first commission for public sculpture from National Endowment for the Arts: "Mermaid", a ten-foot sculpture of steel and concrete for the Theater of the Performing Arts, Miami Beach, Florida.

1979 Elected Member of the American Academy and Institute of Arts and Letters.

1981 Retrospective exhibition of work from the 1970s organized by Saint Louis Museum that travels in the United States, Europe, Japan.

1982 Takes a loft in Manhattan in addition to his Southampton studio.

1983 Paints *Greene Street Mural,* Leo Castelli Gallery, 142 Greene Street, New York.

1984 Exhibition of drawings, James Goodman Gallery, New York.

1986 Unveiling of *Mural With Blue Brushstroke* in the lobby of the Equitable Life Assurance Society building in New York.

1987 Retrospective exhibition of drawings at the Museum of Modern Art, New York. (Also shown in Frankfurt, 1988)